Black Artists and Abstraction 1964–1980 **Energy**

Experimentation

Black Artists and Abstraction 1964–1980 Energy Experimentation

Frank Bowling / Barbara Chase-Riboud / Ed Clark / Melvin Edwards / Fred Eversley / Sam Gilliam / Daniel LaRue Johnson / Tom Lloyd / Al Loving / Joe Overstreet / Howardena Pindell / Haywood Bill Rivers / Alma Thomas / Jack Whitten / William T. Williams

STUDIO MUSEUM HARLEM

At Altria Group we have funded the arts for over 50 years with a focus on programs that take risks and challenge artistic boundaries. It is in this spirit that we are co-sponsoring *Energy/Experimentation: Black Artists and Abstraction, 1964–1980*, the first major survey of black abstract artists committed to exploring non-objective visual language to express their artistic freedom.

The artists represented in this exhibition emphasized form, color and technique, rejecting the figurative images preferred by their contemporaries. Their work fused social and political allusions with elements of abstraction, creating an important yet underappreciated chapter of the Black Arts Movement.

We thank The Studio Museum in Harlem, a friend and partner for more than 30 years, for presenting this important show and providing the exposure these artists so duly deserve. We also salute Dr. Lowery Stokes Sims and Thelma Golden for their leadership in creating a forum for provocative and exciting discussion on the broader historical context of African-American art and artists.

Jennifer Goodale
Vice President of Contributions
Altria Group, Inc.

The Henry Luce Foundation is proud to sponsor the exhibition and catalogue *Energy/Experimentation: Black Artists and Abstraction, 1964–1980* at The Studio Museum in Harlem. The project revisits a significant yet widely overlooked period in American art history, when an influential coterie of African-American artists was committed to creating abstract work at a time better known for more explicit, figurative artistic expression.

As a supporter of American visual art for nearly a quarter of a century, the Luce Foundation's American art program has distributed more than $100 million to museums, universities and service organizations in 47 states and the District of Columbia to enhance the research and presentation of American art. We salute The Studio Museum in Harlem for organizing *Energy/Experimentation* and bringing these expressive, beautiful and important contributions to the public.

Michael Gilligan
President
The Henry Luce Foundation

This publication was prepared on the occasion of the exhibition
Energy/Experimentation: Black Artists and Abstraction, 1964–1980
The Studio Museum in Harlem, New York
April 5–July 2, 2006

Energy/Experimentation: Black Artists and Abstraction, 1964–1980 is presented
with major support from Altria Group, Inc., and The Henry Luce Foundation.
Additional funding is provided by The National Endowment for the Arts.

Library of Congress Cataloging-in-Publication Data
Energy/Experimentation: Black Artists and Abstraction, 1964–1980
Kellie Jones and Lowery Stokes Sims . . . [et al.].

ISBN 0–942949–31–5

The Studio Museum in Harlem
144 West 125th Street
New York, NY 10027

Contents

9 **Acknowledgements**
 Thelma Golden

11 **Curator's Foreword**
 Kellie Jones

14 **To the Max: Energy and Experimentation**
 Kellie Jones

48 **Discrete Encounters:**
 A Personal Recollection of the Black Art Scene of the 1970s
 Lowery Stokes Sims

72 **Free Jazz and the Price of Black Musical Abstraction**
 Guthrie P. Ramsey Jr.

80 **The Re-selection of Ancestors:**
 Genealogy and American Abstraction's
 Second Generation
 Courtney J. Martin

112 **Black Artists and Abstraction: A Roundtable**
 Louis Cameron, Melvin Edwards, Julie Mehretu,
 Lowery Stokes Sims, William T. Williams
 Moderator: Kellie Jones

127 **Artists' Biographies**

142 **Contributors' Biographies**

144 **Works in the Exhibition**

Acknowledgements

First and foremost, *Energy/Experimentation* would not be possible without the dedication and commitment of Dr. Kellie Jones, the curator of this exhibition. I thank Kellie for her vision and passion, which resulted in this amazing project.

I would also like to thank the supporters of this exhibition for their considerable generosity. This exhibition has been made possible with major support from Altria Group, Inc., and The Henry Luce Foundation, along with additional funding provided by The National Endowment for the Arts.

I am also grateful to the following institutions and individuals for making loans from their collections possible: The Columbus Museum, The General Motors Center for African American Art, Kenkeleba House, The Kitchen, The Metropolitan Museum of Art, The Museum of Modern Art, The Newark Museum, The Solomon R. Guggenheim Museum, The Sragow Gallery, Stella Jones Gallery, The Whitney Museum of American Art, Joy and I.J. Seligsohn, Alicia Loving-Cortes and Anne Bethel.

The catalogue is fortunate to have several insightful and illuminating contributions. I would like to thank the essayists, Courtney J. Martin, Guthrie Ramsey Jr. and Lowery Stokes Sims. I'd also like to thank the artists who participated in the roundtable that is included in this volume: Louis Cameron, Julie Mehretu, Melvin Edwards and William T. Williams.

Many thanks go to the Board of Trustees and the staff of The Studio Museum in Harlem, especially to Lowery Stokes Sims, the Museum's President, who had the vision and foresight to initiate this project during her tenure as Director, and Raymond J. McGuire, Chairman. This exhibition has been coordinated by Rashida Bumbray, Exhibition Coordinator and Shari Zolla, Registrar, and Jerlina Love, research assistant, along with the curatorial department consisting of Christine Y. Kim, Marc Bernier, Rujeko Hockley, and interns Jovan Speller and Kathrin Schmidiger. The catalogue has been conceived and edited by Ali Evans, with the assistance of Savala Nolan and Samir S. Patel. Additional thanks to Eddie Opara and the staff of The MAP Office, New York, including Yoon Seok Yoo and Brankica Kovrlija for their beautiful design of this volume. This project would also not have happened without the contributions of Jared Rowell, as well as Sandra D. Jackson-Dumont, Cheryl Aldridge and their teams.

Lastly, I would like to extend my gratitude to the *Energy/Experimentation* artists: Frank Bowling, Ed Clark, Melvin Edwards, Fred Eversley, Sam Gilliam, Daniel LaRue Johnson, Tom Lloyd (1929–1996), Al Loving (1935–2005), Joe Overstreet, Howardena Pindell, Barbara Chase-Riboud, Haywood Bill Rivers (1922–2002), Alma Thomas (1891–1978), Jack Whitten and William T. Williams. These visionary artists are inextricably linked to the history of The Studio Museum in Harlem and it is an honor to present their work again for a new generation of audiences.

Thelma Golden
Director & Chief Curator, The Studio Museum in Harlem

Last spring, unknowingly, I had what would be my last conversation with Al Loving. As with many of the artists in *Energy/Experimentation: Black Artists and Abstraction, 1964–1980*, I had grown up running in and out of his loft, using his materials, playing with his kids (and minding others). It was only when I got to college that I realized not everyone knew artists, watched or listened to their magic unfold. When I spoke to Al about participating in this project he was excited and said he would help in any way he could. He also thanked me. Not for doing the show per se but for joining their special club, signing up for the work of organizer, writer, interpreter for abstraction and artists of color. He thanked me for continuing on this journey with him. I will never regret it.

My essay in this volume, "To the Max: Energy and Experimentation," is dedicated to Al Loving (1935–2005).

Thanks to the following people for their wonderful assistance with research and the myriad details that go into making any exhibition: Petrushka Bazin, Danielle Elliott, Brandi Hughes and Jerlina Love. Thanks also for support from the Griswold Fund, Yale University and the High Museum of Art, Atlanta, for awarding me the inaugural David C. Driskell Prize in African American Art and Art History. A scholar is nothing without her resources. I am indebted to the Yale University Art and Architecture Library, and all the librarians there, particularly Beverly Lett; New York University's Bobst Library; and the incredible Benny Andrews Archives at The Studio Museum in Harlem. Elizabeth Alexander and Alondra Nelson were early, enthusiastic respondents to this project. I delivered a version of this essay as a lecture for the Department of History of Art and Archaeology, Columbia Uni-

versity. Special appreciation goes to the Institute for Research in African American Studies at Columbia University and its director, Farah Jasmine Griffin. It is wonderful to have here additional essays by Guthrie P. Ramsey Jr., Lowery Stokes Sims and Courtney J. Martin, and the roundtable discussion with Louis Cameron, Melvin Edwards, Julie Mehretu and Williams T. Williams, to provide a larger written context for this project. My deepest gratitude goes to the artists and lenders and to every member of the staff at The Studio Museum in Harlem, particularly Thelma Golden, Director; Lowery Stokes Sims, President; Sandra D. Jackson-Dumont, Education and Public Programs; Ali Evans, Public Relations and Publications; Shari Zolla, Registrar; and Rashida Bumbray, Exhibition Coordinator. Thank you for continuing to make the magic happen. Special appreciation goes to the funders of the exhibition: Altria Group, Inc., The Henry Luce Foundation and The National Endowment for the Arts, who make it all possible.

Kellie Jones
Guest Curator

To the Max: Energy and Experimentation

Kellie Jones

Dedicated to Al Loving (1935-2005)

To the Max: Energy and Experimentation

Kellie Jones

"Figurative art doesn't represent blackness any more than a non-narrative media-oriented kind of painting, like what I do."
Sam Gilliam[1]

The period from the 1950s through the 1970s were a heady, if now almost mythic, time of struggle for African-American civil rights, African independence and youth and antiwar movements worldwide. In the history of art by African Americans, the time is known for the cultural production of the Black Arts Movement, whose images of resistance and African heritage have become icons of the era. Simultaneously, these artists protested for inclusion in American society.

Certainly less discussed is the strong voice of abstraction that developed among black artists around this time in both painting and sculpture, a voice created by a critical mass of practitioners committed to experimentation with structure and materials. Flush with the scientific idealism of 1960s, they wrestled with new technologies, including light- and electronic-based works and explorations of recently invented acrylic paint. Their painted works were frontal, holistic and engaged, to an extent, with geometry or primary forms in the manner of other contemporary trends, including post-painterly abstraction and systemic painting. They moved from the planar into considerations of "objecthood" that signaled minimalism. Most of them did not fall wholly into one camp or style, but rather their works were hybrids formed in unique, individual languages of abstraction, at once iconic and emotional, optical and vibrant.

Energy/Experimentation: Black Artists and Abstraction, 1964–1980 focuses on a core group of artists who continued to stay true to these strategies over time. They also exhibit what Mary Schmidt Campbell has identified as a certain "aesthetic collegiality"[2] characterized by similar experiments with opticality, materials, space, tools and surfaces.

Al Loving
Septehedron 34, 1970
Synthetic polymer on canvas
88 1/4 x 102 3/4 inches
Collection of the Whitney Museum of American Art, New York, Gift of William Zierler, Inc. in honor of John I. H. Baur, 74.65

William T. Williams
Untitled, 1969
Screenprint on paper
16 x 11 5/8 inches
Collection of The Studio Museum in Harlem, Gift of Charles Cowles, New York, 81.2.3
Photo: Marc Bernier

Mainstream Connections

As segregation was successfully challenged and legally abolished in the 1950s and 1960s, an entire generation of African Americans was able to attend art school. Not only did they receive the skills and credentials necessary to survive as artists, but the social process itself integrated them into the mainstream art world. Many of the practitioners featured in *Energy/Experimentation* received bachelor's and master's degrees in art from renowned institutions such as Cooper Union, the Art Institute of Chicago and the Pratt Institute. Barbara Chase-Riboud (MFA, 1960), Howardena Pindell (MFA, 1967) and William T. Williams (MFA, 1968) all attended Yale University School of Art, along with Robert Mangold (MFA, 1963) and Brice Marden (MFA, 1963), and it is interesting to consider the shared legacy of color and geometric vision they may have inherited from Yale's influential teacher, Josef Albers.

These artists were also employed in mainstream institutions. Jack Whitten and Williams were professors at Cooper Union and Brooklyn College, respectively. Pindell worked for a decade at the Museum of Modern Art (1967–1977), rising to the position of Associate Curator of Prints and Illustrated Books. There she met Lucy Lippard; Mangold, Robert Ryman, Sol LeWitt and Dan Flavin were employed there as well, mostly as guards. These African-American artists were also among the first residents of SoHo and helped transform it into an artists' neighborhood. Al Loving lived in a loft on the Bowery in the same building as Kenneth Noland; Joe Overstreet, Haywood Bill Rivers, Daniel LaRue Johnson, Pindell, Whitten and Williams were neighbors.

They participated in Whitney Annuals and Biennials, Biennials at the Corcoran and numerous other museum and gallery shows, as well as the plethora of culturally specific exhibitions in mainstream and newly minted alternative venues. Loving and Alma Thomas were the first African-American man and woman to have solo shows at the Whitney Museum of American Art.[3] The Studio Museum in Harlem figures centrally in this narrative as well.

Abstract Art and Protest

In the Black Nationalist atmosphere of this period, many of these artists were rejected by more militant practitioners and institutions that believed figuration was a more useful way to combat centuries of derogatory imagery centered on people of African descent. Abstraction was characterized as "white art in blackface," but without the subjects and artifacts of colonialism—the people and art of the Americas, Africa and Oceania—

where would Picasso (or Matisse, etc.) or their heirs really be? As we shall see, it is fascinating how black abstractionists of the 1960s and 1970s negotiated such dogmatism and rejection. They were committed to equality, but they were equally committed to their right to aesthetic experimentation.

Experimentation

Antecedents

Haywood Bill Rivers, Edward Clark and Alma Thomas were among the first artists in *Energy/Experimentation* to test abstract languages. Thomas was a junior high school teacher for decades and created art in her kitchen before being "discovered" by the mainstream in the 1960s. Rivers and Clark found inspiration and support in France in the 1940s and 1950s, respectively. Both were creating fully non-objective canvases by the 1950s. Returning from Paris and settling in New York in the 1950s, Clark shifted from the more static geometry of cubism to the gestures of American action painting. His hunger for action took him right off the canvas and onto what was arguably one of the first shaped canvas of the period.[4]

Creative antecedents were also vernacular. The incorporation of sewing into the work of Al Loving, Sam Gilliam and Joe Overstreet at this time evoked family traditions of quilting and tailoring. These were functional arts that African Americans had used to earn a living and keep their creative juices flowing at the same time.[5] In this way Alma Thomas saw herself surrounded by creativity from an early age, from her mother's use of color as an expert seamstress to her extended family's planting and working of Southern soil.[6] For William T. Williams, it was the patterns of raked yards the artist created in childhood visits to North Carolina under the watchful and aesthetically keen eye of his grandmother.

The categories of experimentation that I discuss below are useful but random to a certain degree. All of the artists in *Energy/Experimentation* can fit in almost any area. Changing notions of what constituted the art object led these artists toward hybrid forms that pointed out tensions between painting and sculpture, and challenged the strict delineation of the two.

Opticality

Opticality is a term linked to this era and the American art criticism of Clement Greenberg and Michael Fried. It implies aesthetic perception and the intersection of color, composition and materials to create visual dynamism. In Loving's cubes and

William T. Williams
Untitled, 1969
Screenprint on paper
16 x 11 ⅝ inches
Collection of The Studio
Museum in Harlem, Gift of
Charles Cowles, New York, 81.2.4
Photo: Marc Bernier

William T. Williams
Trane, 1969
Acrylic on canvas
108 x 84 inches
Collection of The Studio Museum
in Harlem, Gift of Charles Cowles,
New York, 81.2.2
Photo: Becket Logon

Alma Thomas
Air View of a Spring Nursery, 1966
Acrylic on canvas
48 x 48 inches
Collection of the Columbus Museum,
Georgia; Museum Purchase and Gift of
the Columbus-Phoenix City National
Association of Negro Business Women,
and the artist

Daniel LaRue Johnson
Homage to Rene d'Harnoncourt, 1968
Painted wood
58 ½ x 30 ⅝ x 20 inches
Collection of Joy and I.J.
Seligsohn, New York
Photo: Marc Bernier

Fred Eversley
Untitled, 1972
Cast polyester resin
36 ¼ x 10 ⅝ inches
Collection of the Solomon R.
Guggenheim Museum, New York;
Gift, Spring Mills, Inc., 1978 ,
78.2439

Williams' early geometric paintings, we note the use of masking tape and acrylic paint to create sharp line and eliminate painterly gesture, as was seen in the contemporary work of Frank Stella and Kenneth Noland. Thomas substituted the organizational structure of hardedge with painterly layering that evokes the grid. Daniel LaRue Johnson's sculpture emphasizes the tension between the solid form and its painted surface.

Al Loving's polyhedrons and cubes provided a basis for his early art language. A single cubic word could be combined variably with others to create phrases and sentences, declarations in paint and about space and color. Color could be organizational as well. In retrospect, these hues also represent the era; in the painterly day-glo oranges and pinks of the large work, *Septehedron 34* (1969), we now see the youth and spirit of the 1960s. At the same time, Loving's geometric profile is "polished and tasteful."[7]

A confluence of events in the early 1970s led Loving to change aesthetic gears. He began to think more about the quilt as creative form. His work as a dancer with the Batya Zamir Dance Company further attuned him to space and environment. Another event was more extreme—a laborer completing one of Loving's large public commissions in Detroit was fatally injured. Horrified, Loving decamped to Newfoundland, Canada, cut up all his geometric paintings, learned how to sew and began piecing them back together.

Such antiformalist works as *Untitled* (c. 1975) are diametrically opposed to the hardedge painting that initially won him recognition in New York. He used standard-issue cotton duck, but worked with other fabrics as well, such as velvet, which brought sensuous texture to his surfaces. Each canvas strip also became a painting in and of itself. This explosion of the flat illusionistic object released the artist onto a trajectory of ebullient and continuous experimentation. Romare Bearden provided additional inspiration for this dislocation of painting. His cutting and reassembling of his Abstract Expressionist pieces led to the collages for which he became well known. This made Loving realize that his disassembling of the cubes was a form of collage and a way to make paintings work in real space. He also came to understand the limits of the category of "painter." As he recalled, "that aspect of me doesn't paint but makes things. But I'm not a sculptor."[8]

In the early work of William T. Williams, color became structure, "geometric labyrinths"[9] and planes of intersecting hues. Williams said of these paintings that he was interested in bringing an "irrationalism" to the formalism of the day as a vehicle for emotion and expression. As he has noted, "I was

caught between two issues: an interest in Colorfield painting and an interest in expressionism, and in trying to reconcile the two."[10] Because of his geometric motion and emotion, his works certainly were not experienced in the same manner as typical Colorfield paintings, but people were still drawn to his handling of color. Williams also found the complexity he sought in his paintings in the jazz stylings of the moment. The dynamic geometries in *Trane* (1969) visualize the sounds of John Coltrane's saxophone. Williams sought out jazz for formal inspiration, but also for its "reassertion of cultural identity."[11] To drive home his point, at the opening of his solo show at SoHo's Reese Paley Gallery in 1971, Williams showed the paintings along with "the musical accompaniment of blaring radios."[12]

Linked with the Washington Color School, both Alma Thomas and Sam Gilliam found support for their work in that city in the 1960s. While the majority of the artists in *Energy/Experimentation* were in their 30s during this period, Alma Thomas was in her 70s. Nevertheless, she was clear that regardless of age, she and her work were part of the current "day in time."[13] While her art may have been inspired by the natural world, she said, "I leave behind me all those artists who sit out in the sun to paint. I leave them back in the horse and buggy time when everything moved slowly. I get on with the new."[14]

Thomas found a non-objective language that honored the flat picture plane that had captivated Western modernism. While there is no depth to her paintings, there are layers. Her painted strokes began primarily as gatherings of horizontal lines, thin bands of color, as in *Air View of Spring Nursery* (1966). These blocks of color at times obliterate the canvas field but still evoke an underlying grid. Thomas's excitement for the natural world set her apart from figures such as Noland and Morris Louis. Yet when she translated circular beds of flowers throughout the city into circular imagery, it could invoke comparisons with both Noland and Jasper Johns. She also chose the eccentricities of the brush over the staining of canvas and the sharp, clean lines favored by her peers.

Daniel LaRue Johnson was born in Los Angeles and began his formal art training there in the late 1950s. By the 1960s he lived a peripatetic lifestyle, going back and forth between, primarily, Los Angeles and New York. In the second half of the 1960s his interests in various media came together in highly polished polychrome wood sculpture linked, due to its decorative sheen, to the "finish fetish" of Los Angeles art. An exquisite and complex composition such as *Homage to Rene d'Harnoncourt* (1968) focuses on the horizontal thrust of sculptural forms with a variety of intersecting planes that seem to float above the floor. Shown in the exhibition, *In Honor of Dr. Martin Luther King, Jr.* at the Museum of Modern Art in 1968, Johnson's piece seems from our perspective to have a satiric edge, as it is an homage not to the slain civil rights leader but to a director of the museum. Within months of the exhibition's opening, however, d'Harnoncourt retired and then met with an untimely death soon after. d'Harnoncourt's interests in Mexican and Native American art could be seen, in one sense, as paving the way for a more complex notion of modernism and contemporary culture, and one that might more fully include black artists.

Materials

While Fred Eversley and Tom Lloyd worked with materials considered part of the cutting edge—plastic resin for Eversley, electronics and light for Lloyd—Sam Gilliam took the more traditional notion of painting into another realm. For these artists, the investment in action, and the changing notion of what materials could be considered "art" and how they were used, provided the basis for their continuing explorations.

Fred Eversley, a former aerospace engineer turned artist, began creating cast-plastic resin sculpture in Southern California in 1968. His ideas fitted comfortably into the stylistic trends of the era known as the "L.A. Look"—including hardedge painting, minimalist sculpture and pop art visions—which critic Peter Plagens called "cool, semi-technological, industrially pretty art."[15] It was identified with new techniques and materials, such as resins, glass, plastic, metal and industrial pigments, in works by artists such as Larry Bell, Judy Chicago and Craig Kauffman. The style favored primary forms over decorative surfaces, the inspiration of West Coast aerospace technology over East Coast industrialism. Eversley's sculpture addresses opticality, perception, mathematical formulas and kineticism. While pieces such as *Untitled* (1970) and *Untitled* (1971) are solid geometrical structures, they use kaleidoscopic properties to conjure the movement of bodies in space and reflect viewers' shifting emotional profiles.

Like Eversley, Tom Lloyd used materials that visibly incorporated new technologies. If Dan Flavin's light works create atmosphere and Keith Sonnier's use neon as expressionistic gesture, Lloyd's pieces reflect the movement and pacing of the city—street and traffic lights, automobile signals and theater marquees. Their programmed and changing hues also seem to insert an emotive flair. Large sculptural geometry is further complicated by the form of the lights themselves: circular lenses that refract and fracture light and color; add line, pattern and shape; and alter the holistic sense of each piece. *Moussakoo*

Tom Lloyd
Moussakoo (from the *Electronic Refraction Series*), 1968
Electronic sculpture, aluminum, light bulbs, plastic laminate
54 x 64 x 15 inches
Collection of The Studio Museum in Harlem, Gift of The Lloyd Family and Jamilah Wilson, 96.11

Sam Gilliam
Gram, 1973
Acrylic on canvas
57 x 60 inches
Collection of the Detroit Institute of Arts, Gift of Patricia A. Fedor and Christopher T. Sortwell, 1986.66

Joe Overstreet
Saint Expedite A, 1971
Acrylic on canvas
62 x 96 inches
Courtesy of the artist and Kenkeleba Gallery, New York

Melvin Edwards
The Lifted X, 1965
Welded steel
65 x 45 x 22 inches
Courtesy of the artist
Photo: Marc Bernier

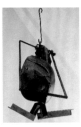

Melvin Edwards
Cotton Hangup, 1966
Welded steel
26 x 30 x 20 inches
Collection of The Studio Museum in Harlem, Gift of Mr. and Mrs. Hans Burkhardt, 91.21

(1968), a wall work around six feet square in size and made up of interconnected hexagons, is among Lloyd's most complex pieces in this medium and mirrors Al Loving's investigations of this shape during the same period. Loving's paintings suggest an easy seriality and interchangeability, while Lloyd's floating light plays belie the connectedness of electronics and wiring that precludes actual physical movement. Instead the light and color offer evanescent motion.

Though he was working with hardedge abstraction as early as 1964, in 1968, Sam Gilliam's experiments with staining and folding canvas exploded into the draped works for which he is perhaps best known: huge skeins that pushed the notion of the Washington Color School into new dimensions. Such works made us rethink what painting might be, what it looked like, how it worked or lived in the world. Yet at no time did Gilliam himself see these as forms of sculpture, instead he considered them "suspended paintings."[16] The painted surface is still the key and the voluminous folds of canvas highlight and emphasize luminous color. By moving the painting off the stretcher bars and into space, the artist acknowledged the "properties inherent to canvas itself ... allowing the canvas to be exactly what it really is—a flexible, drapeable piece of cloth," and let this provide the structure for his imagery.[17] Yet as has been suggested, the installation of the suspended paintings was not random. Gilliam had specific notions about the way he saw the works engaging with space that can be usefully compared to the felt works of Robert Morris or the synthetic skeins of Eve Hesse, which also date from this moment.[18]

Gilliam's investigations of monumental drapes were accompanied by explorations on a smaller scale. Works such as *Gram* (1973), included in *Energy/Experimentation*, demonstrate the importance of circular shapes evolving from the larger cascading pieces. The tondo form became an extension of investigations that problematized the traditional rectangle of modern painting. *Toward A Red* (1975), though completed only two years after *Gram*, shows Gilliam putting paintings back on stretcher bars and in a rectangular format. Where the draped works demonstrated exuberant staining, the surface of *Toward A Red* is thick with encrusted layers of paint, and though more traditional in shape, is formed by joined collaged strips of canvas of varying sizes. It can be usefully compared with Al Loving's *Untitled* (c. 1975), which uses a similar structure of pieced canvas sections, although in this case they are dyed and released from the stretcher.

Space

The notion of space as a sculptural equation is demonstrated in works by Melvin Edwards and Barbara Chase-Riboud, but their approaches take us in other directions, with pieces that may be suspended from the ceiling or lie on the floor. In contrast to Edwards and Chase-Riboud, who manipulated metals, Joe Overstreet transferred the workings of mass and volume to billowy canvases stretched with rope and experienced in three dimensions.

Joe Overstreet left the Bay Area in 1958 for New York, where he received good responses to his work over the next decade. In 1969, he showed intensely hued hardedge and shaped canvases in a solo exhibition at The Studio Museum in Harlem.[19] Overstreet received praise in *The New York Times* and a stellar review in *Arts Magazine*, where his colleague Frank Bowling declared, "This show is a triumph!"[20] He lauded Overstreet's emotional color and edgy sense of shape, and wrote, approvingly, that "The wall is not dealt with formally, but with utter distrust."[21] These shaped canvases, with titles such as *Tribal Chieftain* (c. 1969) and *He and She* (1969), are results of a period of study of "African systems of design, mythology, and philosophy," distilled to make a "statement as a black man in the West."[22] If ethnically specific institutions such as The Studio Museum in Harlem began to move away from works of non-objective abstraction around this time, it seems odd that such works by Overstreet would find approval. But his interest in African design systems, particularly the sense of frontality and confrontation of the mask form, made the works acceptable under the new dispensation.[23]

Rather than find Overstreet's invocation of African symbology situational or opportunistic, we can relate it back to his home base in the Bay Area. There he was mentored by Sargent Johnson, a Harlem Renaissance-era artist who was not only an ardent proponent of Alain Locke's theories, but also, like most West Coast artists, had an open approach to a multiplicity of cultural sources.[24] Overstreet returned to the Bay Area from 1970 to 1973 to teach at California State University, Hayward. During this period he developed the *Flight Patterns Series* and related works, which saw canvases removed from the stretchers. *Saint Expedite A* (1971) is a beautiful example. He transferred the geometry he worked with previously to more flexible formats that indeed bear out Bowling's earlier observation of Overstreet's "distrust" of the wall. These pieces take shape through taut ropes that attach to the floor, ceiling and wall at strategic points. The hues in *Saint Expedite A*—in acrylic paint applied to the ground with a wire brush—appear to be red, black and green, an invocation of the colors of black liberation, a way perhaps to link this work to the social concerns of the day.[25] In the *Flight Pattern Series*, the flexibility of installation and the attention to the canvas as fabric and as a sewn form are attributes Overstreet shared with Loving and Gilliam. But while Gilliam and Loving both referred back to quiltmaking as an impetus for that process, Overstreet was captivated by nomadic shelters, home spaces that can be easily assembled and disassembled to provide shelter on the road and when in flight.[26]

Before arriving in New York in 1967, Melvin Edwards was a rising star in Southern California, garnering major attention there by the age of 30. *The Lifted X* (1965), included in *Energy/Experimentation*, was made for his first solo museum show at the Santa Barbara Museum of Art that same year, and is an homage to the then recently assassinated Malcolm X. Similar to the *Lynch Fragments* series for which he is perhaps most well known, *The Lifted X* contains a strong vertical mass of welded fragments that seem to hold together only tentatively, forming compositional chiaroscuro in the interstices of the welded steel. In *The Lifted X*, however, this central form rests on a cool rectilinear base.

The sense of ritual and eroticism that Mary Schmidt Campbell read in the *Lynch Fragments* is not yet quite visible in *The Lifted X* or *Cotton Hangup* (1966).[27] Both seem more experimental. The latter is hung from the ceiling and anticipates more environmental works such as *Curtain for William and Peter* (1969). That work is composed of barbwire and chains, which cascade from the ceiling to the floor, and had its debut at The Studio Museum in Harlem in 1969 in the exhibition *X to the 4th Power*, curated by William T. Williams, before being included in Edwards' solo show at the Whitney Museum of American Art the following year. However, as early as 1968, Edwards was experimenting with large-scale geometries that were sometimes painted. These were shown at his one-man show at the Walker Art Center in 1968 and appeared in a public work, *Double Circles* (1968, installed 1970), in Harlem at 142nd Street and Lenox Avenue.

Barbara Chase-Riboud has spent the last four decades living and working in Europe, but her art is still intricately involved with the issues faced by this generation of artists and the tensions between abstraction, politics and race. She also continues to be concerned with themes of the African Diaspora. A sculptor and an erudite draftsman, she is also a poet and award-winning novelist.[28] At times her various projects intersect into one continuous study, as we see with the piece *Bathers* (1972), which is also the subject of a poem. The sculpture is a floor work of undulating elegance. It covers nine feet by twelve feet of floor space but rises a mere six inches off the ground. Silk and synthetic fiber appear to erupt from the places where the 16 aluminum sections join, and ooze and flow more flagrantly at certain

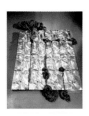

Barbara Chase-Riboud
Bathers, 1972
Aluminum and silk, ed. 3 of 3
6 x 108 x 148 inches
Courtesy of the artist and
Stella Jones Gallery, New Orleans

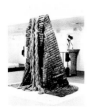

Barbara Chase-Riboud
Le Mantaeu (*The Cape*), 1973
Collection of the Lannan
Foundation, Los Angeles

Jack Whitten
Red Cross for Naomi, 1980
Acrylic on canvas
42 x 42 inches
Courtesy of the artist

Jack Whitten
Khee I, 1978
Acrylic on canvas
72 x 84 inches
Collection of The Studio Museum
in Harlem, Gift of Lawrence Levine,
New York, 81.9

Ed Clark
Untitled, 1974
Color etching on paper
22 x 30 inches
Collection of The Studio Museum
in Harlem, Anonymous Gift, 00.3.3
Photo: Marc Bernier

Ed Clark
Yucatan Series, 1977
Acrylic on canvas
45 ½ x 63 inches
Courtesy of the artist

points. A useful comparison can be made here to the decidedly more minimal work of Carl Andre, which radically offered up sculpture not only as flat piece barely rising from the floor, but also crafted from mundane materials such as firebrick and steel. We can also think about Chase-Riboud's oeuvre as valorizing materials considered craft (fabric, yarns, etc.), part of the changing notions of the art object in this era, and particularly linked to a feminist practice. In this light, French art historian Françoise Nora related Chase-Riboud's work to that of contemporaries, such as Magdalena Abakanowicz and Nancy Graves, in an orientation towards, and revitalization of, fiber.[29]

Chase-Riboud used the lost wax process to cast unique metal elements in her sculpture from the 1970s. An ancient method, it is associated with the exquisite bronzes of 15th- and 16th-century Benin. Correlation to African creative traditions can also be seen in the way Chase-Riboud approached her vertically oriented pieces from the period, such as the *Malcolm X Series*. Here we find parallels to West African masquerades, which join wooden mask superstructures with fabric, raffia and other materials draping the body, and are then put into performance. Yet Chase-Riboud has also been adamant about the fully global inspirations for her work and the need for an equally expansive contextualization.[30]

Tools

New approaches to painting required new types of implements. Jack Whitten and Ed Clark were among those who developed different ways of applying paint to the canvas ground. Their inventiveness was not just in the workings of the flat surface, but in the methods and tools used to intercede in it. These interventions were also about process, where the actions constituting the creation of the work are made/left visible. As Whitten noted, "the painting is more about the journey than the destination."[31]

Although an admirer of Abstract Expressionism and Colorfield painting, Jack Whitten considered his own works as a further development: fields of painted matter that he related to the "sheets of sound" created by jazz musicians and the active surfaces of photography in process. As he explained:

> I had a conversation with John Coltrane, in 1965, at the Club Coronet in Brooklyn. He was playing with Eric Dolphy and for about two weeks straight I was going out there every night to hear him. Coltrane told me how he equated his sound to sheets: the sound you hear in his music comes at you in waves. When they say 'Training in,' it's about the sound coming in in waves. He catches it when it comes by, and he'll grab at as much of it as he needs, or can grasp. I think that,

in plastic terms, translating from sound, I was sensing sheets, waves of light. A sheet of light passing, that's how I was seeing light. That's why I refer to these paintings as energy fields. I often thought of them as two poles that create a magnetic field in which light is trapped. That's the energy.[32]

Paintings of the 1970s, such as *Khee I* (1978), from the artist's *Greek Alphabet Series*, thrust horizontally in thick vibrating bands, with incisions in pale hues interrupting the flowing movement of gray, black and white tones. The working of the surface is elaborate and refined, hinting at the illusionism that was painting's stock-in-trade. Whitten worked in the area of tension between the actual painted planes and the pictorial space. The surfaces he created are also tactile, made by layering and cutting back into thick strata of acrylic. Whitten's experiments make the physical nature of painting palpable.

What distinguished Whitten from his peers, however, was his invention of processes and tools for painting. In 1970 he made a decision to let go of the brush and remove the marks of the hand from the canvas. He created a floor-based platform on which to paint and a variety of objects with which to manipulate or intercede in the liquid surface. The first of these were, tellingly, an Afro-comb and a saw, which he pulled through wet acrylic. The former was a sign of African-American identity and the latter of manual labor and the construction trade in which Whitten worked when he arrived in New York in 1960. These two items inspired an array of inventions, often immense things made of metal, rubber or wood, that the artist pulled across profuse layers of paint. "This technique [was] a physical way of getting light into the painted surface without relying on the mixture of color."[33]

Edward Clark's mature work is a testament to gesture and action. The traditional paintbrush, however, was replaced by a pushbroom in the 1960s to capture not only the motion of the hand and arm, but also to involve the power of the body. With the body behind it, the pushbroom offered speed. As the size of the paintings grew, Clark added a track-like device to keep the broom steady. Clark's voice developed with the intersection of gesture and color. He began to create oval paintings in Paris between 1966 and 1969 as a way to incorporate perception by mimicking the shape of the eye. This form is also a continuation of Clark's shaped paintings of the 1950s. By the early 1970s, the ellipse or oval had evolved into a "bounding shape"[34] contained within the canvas rectangle and which interceded into the strong horizontals formed by the pushbroom, as we see in *Untitled* (1977) from the *Yucatan Series*. During the period covered by *Energy/Experimentation*, Clark created groups of paintings influenced by travel and memory. Paler hues—white, wisps of faintest blue, some beige into a whisper of pink—dominate the *Yucatan Series*, while the *Ife Series* concentrates on terracotta and umbers, for instance, in ruminations on place and culture.

Surface

An involvement with surface in painting is demonstrated in the works of Haywood Bill Rivers, Frank Bowling and Howardena Pindell. Bowling's experimentation with processes of staining in the late 1960s and early 1970s was incrementally replaced with an increased emphasis on layering of painted material. Rivers began creating thick paintings in the 1950s and this became his signature. Unlike the others, Pindell's canvases were largely monochromatic, making the buildup of surface materials almost invisible despite their loaded density.

Haywood Bill Rivers is the oldest artist represented in *Energy/Experimentation*, although he and Ed Clark are of the same generation. Through his example we understand how African Americans marshaled their creativity, whether they were trained formally or not, and regardless of whether anybody cared to recognize what they did as fine art. Born in the small rural town of Morven, North Carolina, Rivers made his way to New York and the Art Students League in 1946. Rivers' earliest work follows the naïf vein of Horace Pippin and owes much to his interest in the work of Jacob Lawrence. Interestingly, one of his mentors at the Art Students League was Morris Kantor, who would turn out to be one of Al Loving's professors in graduate school at the University of Michigan in Ann Arbor some 20 years later.[35]

Rivers developed his fully abstract voice by the 1950s, when he was living in Paris. At that time he developed his heavily impastoed canvases, some of which were so thick that "they could not be rolled for shipment to the United States."[36] Rivers was inspired and captivated by Abstract Expressionism, a movement in which he felt he could participate, and that had national and international impact.[37] *Eclipse #1* (1970) demonstrates the language that the New York art world came to know him by in the 1970s. It is driven by a unique color sensibility and characteristic geometry, and, interestingly, still bears the frontality found in his figurative "naïf" canvases of the 1940s. Rivers, too, thought of his practice in relationship to the traditions of quilting, vernacular and functional creativity. He also saw them as issuing, to a certain extent, from the natural world, as seen in his repeated petal images based on the bountiful daisies of North Carolina. However, the circular forms that reappear in his canvases were inspired by the Moorish architecture of Spain, where he spent time in the 1960s.

Frank Bowling
Bartica Born III, 1969
Acrylic on canvas
114 x 54 inches
Courtesy of the artist

Frank Bowling
Barticaflats Even Time, 1980
Acrylic and oil on canvas
28 x 78 inches
Collection of The Metropolitan
Museum of Art, Gift of Dr. and Mrs.
Robert E. Carroll, 1981 (1981.509)

Howardena Pindell
Untitled #23, 1974
Watercolor and acrylic on board
20 ½ x 16 ⅛ inches
Courtesy of Sragow
Gallery, New York
Photo: A. V. Woerkom

Howardena Pindell
Feast Day of Iemanja II,
December 31, 1980
Acrylic, dye, paper, powder,
thread, glitter and sequins
86 x 103 inches
Collection of The Studio Museum
in Harlem, Gift of Diane and Steven
Jacobson, New York, 86.2

Howardena Pindell
Free, White and 21, 1980
VHS
TRT 12:15
Courtesy of The Kitchen,
New York

Arriving in New York from London in the mid-1960s, Frank Bowling, originally a citizen of Guyana, visually and intellectually confronted the notion of "American-type painting." *Bartica Born III* (1969) demonstrates Bowling's investigation of large stained colorfields. Yet his larger "American" autobiography is also present here in the painting's Guyanese title and furthered in his incorporation of maps and photo silkscreens.[38]

As Kobena Mercer has noted, maps in the works of other artists in the 1960s, Jasper Johns and Alighiero Boetti among them, become vehicles for the exploration of a changing sense of geography. Bowling's figure and actions were part of the global effort to "decentre the planisphere," or the perspective of the globe from the Western eye.[39] But the maps become increasingly vestigial as color takes control. At times juicy and luminous, these paintings also offer, according to Mercer, an "aquatic mood" that relates to the Afro-Atlantic Middle Passage.[40]

While he is discussed here in the context of surfaces, Bowling invented his own tools as well. He built a low platform equipped with a gutter to accommodate the running water and paint of his staining process, and also created canted stretchers to allow paint to course down the center in forms both sensorial and dimensional. In later paintings, such as *Barticaflats Even Time* (1980), our attention is drawn to the thick layering and slubs on the active surface.

Around 1970, Howardena Pindell began to adapt various "systems" to work out aesthetic problems in paper and paint, such as hole-punched templates through which she applied color to a surface. The circular remains of these stencils, as well as fragments of discarded works, were then reapplied to paintings and drawings, sometimes numbered but "out of sequence" and sometimes bearers of delicate color. Underlying this play of surface is a grid, maybe formed of graph paper and later made more three-dimensional with monofilament or thread. Large paintings from the period are light, almost translucent, and seem to merge with the wall, some with barely flickering dots that are iridescent and poetic.

In the practice of Howardena Pindell we begin to see the stakes of painting, and art in general, change as we move toward 1980. Increasingly concerned with the lack of content, and later with the absence of specifically *political* content, in her own work, Pindell began to make surfaces that reflect changing notions of what the picture plane should hold. We see this in the greater incorporation of color, and the sexy fun of shimmery substances—"sequins, confetti, and glitter, like minimalist paintings seen through the eyes of a Vegas couturier," as Carrie Rickey mused.[41] In these later large paintings, Pindell belatedly took up

the craft of sewing—often used to mark feminist practice earlier in the 1970s—to create soft grids from strips of canvas that were then sewn back together but "so loosely bound that the paint-stiffened threads become airy, organic grids."[42] *Feast Day of Iemanja II, December 31, 1980*, evidences such developments in the artist's work. The titular link to the African Diaspora (in this case in the reference to the Afro-Brazilian religion of Candomblé) is something we have seen in other works in *Energy/Experimentation*. But here it is feminized with allusions to the goddess of the sea and of procreation, its sensuous beauty compounded by the addition of perfumed scent. These shifts on Pindell's part moved the work toward what would become post-modern practice in the 1980s—a focus on overt investigations of identity and the return, in painting as well as in sculpture, of the figure.

While she realized the importance of political activism early in her professional career, Pindell did not incorporate that into her painting before 1980. As works of process, Pindell's paintings and drawings from the 1970s could be seen as meditations. However, in 1980 she forecasted a shift: "I do work that tends to be very beautiful, very physical. There's texture, there's color, even smell ... People who see my work now find it very soothing. I want to start confronting people with having to change their attitudes. It's not because I feel I *should* do that; I feel that I physically *must* do that work, or I'll get ill from not doing it!"[43] The evolution in Pindell's paintings—the embrace of figures, lush applications of color and text, and indeed the autobiographical turn, seen in such works as *Autobiography: Scapegoat* (1990) in the collection of the The Studio Museum in Harlem—began with the video performance work, *Free White and 21* (1980), a paean to art/real world racism. In the 12-minute video, Pindell plays all roles. One person is a black woman artist recounting vignettes of discriminatory encounters taken from Pindell's life. Another figure is a white racist, a caricature of a "lady"—Pindell in a blonde wig and white face. The third character is a liminal entity who wraps and unwraps her head with white gauze, which is eerily close to the white canvas strips from which Pindell had been creating her paintings up to that moment.

Energy

"Energy" in the title of this exhibition inflects the "Experimentation" of these artists. Much of it is found in explorations of new materials and technologies, including new formulas of acrylic paint, light, electronics, photography and a translation of photographic thinking.

Corporate Technology

Some of this exploration was imbricated with certain kinds of corporate support. Tom Lloyd created his *Electronic Refractions* in consultation with Al Sussman, a scientist working for the electronics giant Radio Corporation of America (RCA). William T. Williams had a relationship with Lenny Bocour, owner of Bocour Artist Colors (maker of the first acrylic paints), that not only allowed him access to the latest products, but also enabled him to comment on and perfect these materials for his own use. Jack Whitten's fellowship with the Xerox Corporation in the mid-1970s gave him access to flat-plate photocopy equipment. He also created works on paper using dry carbon pigment, or toner. Whitten also had a relationship with Bocour, and traded paintings for large quantities of paint. Fred Eversley's location in Southern California and experience as an engineer made him a perfect candidate for the infamous "Art and Technology" institute at the Los Angeles County Museum of Art, which culminated in an exhibition in 1971. The program matched artists with corporations producing new and specialized materials. Eversley was paired with Ampex Corporation, a maker of audio and visual recording and data technologies, to create a project with heat-sensitive liquid crystals in a full-spectrum, light-filled environment.

Photographic Thinking

Jack Whitten was interested in photography's growing preeminence and the technology's imbrication in contemporary vision; as he wrote on his studio wall during this period, "The image is photographic; therefore I must photograph my thoughts."[44] This was not a nod to figuration but his way of considering the painted surface as something developed and activated by process. Whitten's use of the generic term "developer" for all his invented tools was another link to photographic thinking and method. The close tones, shimmer and keen articulation of his surfaces also draw comparisons to new media, such as television and video.

Howardena Pindell's experiments with minimalist-driven aesthetics signaled both the contemporary and future time. Her sardonic use of numerical systems, grid structures and discarded materials was seen as having "succeeded in making art out of the detritus of the computer age," unlike assemblage, which was experienced through the lens of nostalgia.[45] In the second half of the 1970s, Pindell's explorations of translucence in the painted ground began to move her further towards technology. In her "video drawings" the artist replaced raw canvas with acetate, which she decorated with diagrammatic pen

Alma Thomas
Mars Dust, 1972
Synthetic polymer on canvas
69 x 57 inches
Collection of the Whitney Museum
of American Art, New York,
Purchase, with funds from The
Hament Corporation, 72.58

and ink sketches. She then positioned these acetate cels over a television screen and photographed them at slow speeds so the video image became blurred while the solid ink drawing remained constant. One gets a sense of the works as new hybrid objects, even though they were technically photographs.

Afro-Futurism

Alonda Nelson and other scholars have identified certain types cultural production under the rubric Afro-Futurism, which describes art forms that engage the futuristic, science fiction and technology, but are tethered to histories of the African Diaspora. During the period covered by *Energy/Experimentation*, we see this in the speculative fiction of writer Ishmael Reed and the musical innovations of avant-garde jazz musician Sun Ra.[46] Art historian Françoise Nora has spoken of Barbara Chase-Riboud's *Bathers* in this context. Its floor orientation, along with the conjunction of metal and fiber, gives the piece the quality of something unknown, evoking "a poetic science fiction of the past," similar to the otherworldly black slab in the film *2001: A Space Odyssey* (1968).[47]

Also during this period, Alma Thomas created a series of phenomenal paintings inspired by U.S. space exploration. Thomas was captivated by it all: craft and men, orbiting and landing on the moon, the material of the lunar surface, pictures of other planets—as in *Mars Dust* (1972)—and Earth as seen from the cosmos. Thomas' daubs of color also captured the grainy texture of the televised image and the screens that mediated much of her space imagery.[48] Yet she imagined seeing her visions of earthbound flora from "way up there on the moon"[49] or "planes that are airborne,"[50] as well, even before having flown commerically, which signaled her progressive, forward-looking vision or Afro-Futuristic thinking.[51]

Abstract Art and Protest

Undeniably, aspects of the power and energy manifest in the work on view are also drawn from the era's climate of protest and social change. The artists in *Energy/Experimentation* wanted to be acknowledged for the "artistic merit of their creations, rather than for the social content of their works."[52] However, they also often attempted to make the social ferment of the time present in the work as pictorial and spatial energy, and through themes or titles. The social connotations of this body of work also appeared in its environmental and public aspects; many of the pieces were crafted with the idea of encompassing the viewer, which came from a desire to share this vision, to have people connect with this energy. Some artists were also strategi-

cally involved in actual protest. For most, being an artist and a person of color at this time also meant being an activist or an organizer on some level, if only to bring one's vision into the world.

One watershed was the protest against the exhibition *Contemporary Black Artists in America* at the Whitney Museum in 1971. Although the show was originally an initiative of the Black Emergency Cultural Coalition in conjunction with the museum, objections built as the methods of organization and scholarship came into question. At least 16 artists withdrew from the show to protest the museum's shoddy and haphazard approach to these artists, their work and their history. A letter stating some of their positions appeared in *Artforum*, and was signed by John Dowell, Melvin Edwards, Sam Gilliam, Richard Hunt, Daniel LaRue Johnson, Joe Overstreet and William T. Williams—all abstract artists.[53]

Protest Actions

William T. Williams used a proposal for bringing artists into local communities, a concept he developed as a graduate student at Yale University, to create a template for The Studio Museum in Harlem's famed Artists-in-Residence Program, which, in fact, gave the institution its name. The museum was seen as a location for living artists. The idea was to take artists, and perhaps particularly African-American artists, and put them back into community settings to inspire other kinds of thinking among youth of the inner city. Another goal was to bring art into the urban landscape. In a way, this mirrored what some black artists groups, such as Weusi in New York, the Organization of Black American Culture (OBAC) in Chicago or the Black Arts Council in Los Angeles, were doing at the time. These efforts included holding exhibitions in community centers and banks, on fences and walls, and in other non-traditional locations to attract equally non-traditional audiences. Williams' plan placed both the art world and the artists themselves in the urban community setting, thus taking art out of the realm of elitist culture and putting visual aesthetics within the reach of everyday people.

Williams, along with Melvin Edwards, Billy Rose and Guy Garcia, formed the Smokehouse group, and between 1968 and 1970 created murals for outdoor sites in Harlem. There was a sense then that art in outdoor locales could energize a place and a people and be a catalyst for change. The group's renovation of a small park in Sylvan Court (on 123rd Street in East Harlem) is a good example. After they had worked on the walls, more life seemed to flow into the park—the Parks Department updated seating areas and people from the area began to return to this site, which had previously been abandoned to addicts and the like. Unlike OBAC's famous *Wall of Respect* (1967) in Chicago, which featured figurative renderings of past and present heroes of the African Diaspora, Smokehouse murals were always abstract. The artists nevertheless sought community input at the conceptual stage and at completion, creating a sense of ownership and investment by the neighborhood.[54] The idea was not to preach from walls through politicized or didactic messages, but to bring resources and a sense of the possibilities for transformation.

Tom Lloyd appears in the historical record as more of an activist because of his connection to the founding of The Studio Museum in Harlem, along with his demands for accessibility to art by urban communities, as well as his protests for the diversification of museum exhibitions and collections. Lloyd's series of light pieces, the *Electronic Refractions* opened The Studio Museum to the public on September 26, 1968.

In the beginning The Studio Museum in Harlem focused its energies in three major areas: a schedule of exhibitions, filmmaking for young people and an Artist-in-Residence Program. Such activities marked the museum as incredibly progressive for the time, particularly in the support of African-American artists that had been sorely lacking since the end of the Federal Art Project of the Works Progress Administration (WPA). The filmmaking component also seems quite radical in retrospect, as it involved inner-city residents not only in the creation of art works but also in the manipulation of technology.

When it opened on "upper Fifth Avenue" in the fall of 1968, The Studio Museum in Harlem extended "Museum Mile" up to 126th Street. But as Grace Glueck commented almost a year later, there was ambivalence towards what was viewed as the encroachment of the dominant culture into the spiritual home of the black world.[55] In that first year, questioning of the museum's leadership and aesthetic profile by community residents and "militants" led to early changes, a backlash against what some saw as the Museum of Modern Art transplanted to the inner city.[56] Even Lloyd's opening show was viewed as "irrelevant."[57] While *The New York Times* reported that a mishap by a drunk was responsible for damage to one of Lloyd's pieces on opening night, in a recent interview William T. Williams confirmed a black historical urban legend that had ascribed the damage to the ire of the some of the crowd, a stance subsequently borne out by the museum's move away from non-objective abstraction.[58]

Lloyd continued with his own radical activities to force U.S. cultural institutions to recognize and support the contributions of black people to the visual arts. Between 1969 and 1970

he was a major force in the interracial Art Workers Coalition, which specifically targeted the Museum of Modern Art, insisting the museum become more open to the work of a diversity of contemporary artists and audiences. From 1970 on, Lloyd's art activism turned to his home borough of Queens. After setting up the Community Artists Cultural Survey Committee to assess and identify the cultural needs and wants of non-elite art audiences in the New York area, he founded the Store Front Museum/Paul Robeson Theater in the neighborhood of Jamaica in 1971. The same year he joined the board of the newly formed Queens Museum. Until 1986, he was director of the Store Front Museum, which he viewed as a place to support creativity far removed from Manhattan's elite halls of culture.[59]

Activism became an ever-important force for Melvin Edwards. In California he was active in protests against housing discrimination. He also worked directly with Mark di Suvero in 1966 in the construction of the Los Angeles Peace Tower, a monumental work that used a steel structure as a framework for hundreds of two-foot square paintings contributed by an array of international artists protesting the war in Vietnam.[60]

Edwards' radical thinking was also reflected in several artist's statements of the period. One appeared in conjunction with his solo show at the Whitney Museum in 1970.[61] Another missive, "Notes on Black Art," written in 1971, gained wider circulation in 1978 when it was published in the catalogue for his solo show at The Studio Museum in Harlem. It is fascinating to review the definition of the term "black art" given by someone working three-dimensionally and always abstractly, especially in light of the push for didacticism and figurative representation that was heralded as the authentic role of the black visual.

Edwards defined "black art" as "works made by black people that are in some way functional in dealing with our lives here in America."[62] For Edwards, "The work can either take the form of giving and using ideas, subjects & symbols for radical change, or the works can be of such large physical scale, and in the right places, as to make real change. It should always be known that these works are our methods of changing things."[63] It is interesting that Edwards' definition left room for abstraction by defining content as "subjects & symbols"—linking two perhaps diametrically opposed camps through an ampersand. The "large physical scale" he mentioned also reflected his own investigations of public art and monumental sculpture at that moment, including the work with the Smokehouse group.

Some types of activism were more situational and pressed the point about black creativity and the existence of black abstractionists through a certain type of visibility, through par-

ticipation in group exhibitions of black artists and at the level of content. Activism by Al Loving, Fred Eversley and Daniel LaRue Johnson can be viewed in this light.

When Al Loving landed in New York in early 1969, protests against the *Harlem on My Mind* exhibition at the Metropolitan Museum of Art were in full swing. He arrived at the museum to see the show and instead joined the picket line, where he met numerous black artists—many included in *Energy/Experimentation*.[64] Coming from Detroit, Loving had been exposed to "black art" by street artists or through work on display during conferences held by the radical Reverend Cleage. As Loving recalls, "There were paintings of people in struggle, people in chains, slaves, romantic pictures of Africa, and so on."[65] Even before arriving in New York he began to question this notion of "black art," which seemed to be at odds with all that he had been learning about aesthetics in his BFA training. "Was art supposed to be propaganda for the Civil Rights Movement?"[66] He made a decision to keep his commitment to radical politics out of what he created on canvas.

During the 1960s and 1970s, the figurative and didactic demands of the Black Arts Movement intersected with mainstream society's putative requirement that creative culture by black people "be heavily sociological in content."[67] Nevertheless, Fred Eversley's cast-resin sculptures were included in many shows of black artists during this time, as were Tom Lloyd's light works.

Throughout the 1970s, Daniel LaRue Johnson dedicated himself to the completion of a public monument to Ralph J. Bunche, a winner of the Nobel Peace Prize and a United Nations undersecretary-general who died in 1971. Finally dedicated in 1980, *Peace Form One*, a 50-foot stainless steel obelisk, is located at 47th Street and First Avenue in a small park outside the United Nations complex in New York.

The youngest artist in *Energy/Experimentation*, Howardena Pindell most exemplifies the problematizing of a monolithic black identity at the end of the 1970s and the rise of black feminist thinking, which was also epitomized by the rising prominence of authors such as Toni Morrison, Alice Walker and Ntozake Shange. Additionally, Pindell's practice demonstrated the changing nature of art, the move toward the greater visibility of content, figuration, density of the painted surface and, finally, the decentering of Western master narratives in favor of a more global sense of art and culture. Pindell's travels to Africa, Asia and South America got her thinking about using models other than Western ones as paradigms for the art-making process. Even before that, however, her interaction with feminist circles demonstrated her broader thinking on black identity.

Pindell was among the founding members of the feminist SoHo coop gallery A-I-R in 1972.[68] Such galleries were part of the alternative space movement, found parallels with ethnically specific spaces such as The Studio Museum in Harlem and were created to provide exhibition opportunities for a cadre of artists, in this case women, who were denied exposure in the larger mainstream art world. The feminist sector first showed the greatest support for Pindell's work. Yet after several years of active participation and exhibition with A-I-R, Pindell resigned because of the continuing specter of racism within feminist ranks. Her video performance *Free White and 21* is an allegorical meditation on some of these experiences.[69]

Pindell's activism continued in the late 1970s with participation in the Committee Against Racism in the Arts, formed in response to the exhibition *The Nigger Drawings* at New York's Artists Space in 1979. Using public funds, this alternative space mounted a show of charcoal drawings by a white male artist under the pseudonym "Donald," who chose the racial slur as the title of the series and sparked controversy in the art world.[70] In the 1980s, Pindell took this energy and expanded it into several projects that focused specifically on racism in the realm of culture. Her documentation of discriminatory practices first appeared as the article, "Art World Racism: A Documentation," in the *New Art Examiner* in 1989. She revisited the project in the 1990s and it was published in an expanded version in a book of Pindell's writings, *The Heart of the Question: The Writings and Paintings of Howardena Pindell*.[71]

In the example of Haywood Bill Rivers we see how the energy of protest set the artist's career flowing. When he left North Carolina at 16, his first stop was Baltimore. Like many budding black artists of his generation, he was initially accepted to art school, at the Maryland Institute College of Art (MICA), only to be rejected when he arrived at the school to begin his study. The National Association for the Advancement of Colored People (NAACP) was then brought in to argue Rivers' case. Though he did not win admittance to MICA, the state government gave him a scholarship to study anywhere outside its boundaries. Rivers chose to come to New York and work at the Art Students League in 1946. By the end of the 1940s he had joined Knoedler Gallery, exhibited at the Carnegie International of 1949 and ironically had a solo show at the Baltimore Museum, which also purchased several pieces.[72]

Rivers' experience was evidence of the way things had been for African-American artists in previous periods, particularly those who were too young to have participated in the WPA. The 1960s and 1970s were a testament not only to the new social

Romare Bearden
Conjure Woman, 1964
Photo projection on paper
64 x 50 inches
Collection of The Studio Museum
in Harlem, Gift of the artist, 72.5

status that black people were demanding of this country and the world, but also to how this energy translated into new kinds of opportunities for creative culture.

If Romare Bearden proved to be a mentor to others during the period covered by *Energy/Experimentation*, Haywood Bill Rivers filled a similar role. Jack Whitten has recounted Rivers' importance to younger black artists in New York at that time, and the artist's Bowery loft was an important meeting place even in the early 1960s. As Whitten recalls:

> The one thing that Bill impressed upon me was that there were ideas in art to work with ... Today formalism has become a political key word and it is wrong that it has become that. Every painting has a degree of formalism in it. You can't do a painting without thinking of formalist tenets in some way. [And then there is] the connection of painting as a larger, universal means, the connection of painting as a possibility of showing world view, world vision ... Bill Rivers was the one who set up that sort of atmosphere. Because of his painting, his involvement with painting, his lifestyle, he enabled me to become acquainted with these sorts of ideas.[73]

Joe Overstreet's contribution to the political and social energy of the period was significant and lasting. Shortly after his return to New York in 1974 after three years in the Bay Area, he opened Kenkeleba House Gallery on the Lower East Side with his partner, Corrine Jennings. The two made a commitment to offer exhibitions for artists of color and others who were underserved by the visual arts institutions of the day. Kenkeleba House, whose name was inspired by an African medicinal plant,[74] was a significant part of the culture of alternative spaces that grew in the 1970s and 1980s in New York that offered opportunities not only for artists, but also for curators and writers to develop and ply their craft.[75] In addition to gallery space, Overstreet and Jennings made studios and living spaces available in the building on East Second Street.

Texts of Protest
Rather than engage in physical protest activities, some artists made their radical thinking known through published criticism, statements and interviews.

In addition to being a painter, Frank Bowling was a contributing critic to various art magazines during the late 1960s and early 1970s. He penned a number of significant articles in which he attempted to unpack notions of that troublesome term, "black art." His ruminations on material aspects of black life, struggle, jazz and, importantly, a global framework for

black experience, were key contributions to artistic dialogues of the era.[76]

Part of Alma Thomas' allure for the art world was her apparent profile as an older, untrained folk artist and *proper Negro lady*. Because she was of a different generation than the majority of artists emerging in the 1960s, her approaches to social issues and to notions of art and race were different, though I would argue not necessarily less radical. In fact, her views clearly reflect the tenor of the Harlem Renaissance of the 1920s and its emphasis on presenting black cultural accomplishment as the key to ending racism.

Responding to the critic Eleanor Munro's query, "Do you think of yourself as a black artist?" Thomas replied, "No, I do not. I am a painter. I am an American. I've been here for at least three or four generations. When I was in the South, that was segregated. When I came to Washington, that was segregated. And New York, that was segregated. But I always thought the reason was ignorance. I thought myself superior and kept on going. Culture is sensitivity to beauty. And a cultured person is the highest stage of the human being. If everyone were cultured we would have no wars or disturbance. There would be peace in the world."[77]

In interview after interview Thomas reiterated, if subtly, the role racism and segregation played in organizing her life choices. Born with speech and hearing impediments that perhaps drove her toward an inner creative life, she also cast her physical challenges as an apocryphal tale of white supremacy: as she mused, "My mother always thought [my handicaps] were because before I was born, a lynch party came up the hill near our house with ropes and dogs looking for someone" and the fear that the incident created caused Thomas' disabilities.[78] As a child she moved with her family from Columbus, Georgia, to Washington, D.C., because "there was nowhere I could continue my education ... At least Washington's libraries were open to Negroes, whereas Columbus excluded us from its library."[79] Indeed, she went on, "there was only one library in Columbus and the only way to go in there as a Negro would be with a mop and bucket to wash and scrub something."[80]

Like Alma Thomas, Ed Clark was of a different generation than the majority of artists gathered in *Energy/Experimentation*. In an interview with Judith Wilson in 1985 he admitted to not being so comfortable with the notion of a segregated "black art." He felt that artists should have the opportunity to be with and learn from each other, and he was equally uneasy with the way grouping artists by race automatically shifted interest from the creative work to politics. However, he also admitted that while he was uncomfortable with such notions, the focus brought to the work of black artists during the 1960s and 1970s affected him positively in other ways, leading to greater visibility and sales.

Clark lived in Paris from 1951 to 1956, moved to New York for a decade and then returned to Paris between 1966 and 1969. While back in Paris in the 1960s he made some of his most caustic political commentary regarding the situation of black artists in the U.S. In a statement for *L'Art Vivant*, a publication of the Galerie Maeght, on the occasion of the opening of The Studio Museum in Harlem in 1968, and in an interview the following year in *L'Express,* Clark was vocal about the dearth of opportunities for black artists in the U.S. and the lack of encouragement and support, a lack that leads to a curtailment of possibilities and prospects.[81]

The naming of works became another way to connect with black social struggles of the time. We see this in the series of canvases that Sam Gilliam made in response to the death of Martin Luther King Jr. and the subsequent riots in Washington, D.C.[82] Another example is *Three Panels for Mr. Robeson* (1975), large-scale drapes shown at the 34th Corcoran Biennial.[83] He referred to these works as "heraldic," not typical works of protest art but meditations, as Barbara Chase-Riboud has noted of her *Malcolm X Series*. While Gilliam has spoken of the Baroque gestures of his suspended paintings, he has also addressed their relationship to African masquerade forms. Such connections can be seen in the implied movement of Gilliam's work and its links to dance. Other pieces from the 1970s by the Washington, D.C.-based artist, in which yards of material entwine wooden beams and embrace solid sawhorses, bring to mind the interaction between wood and fabric in the masquerade models. Mary Schmidt Campbell continued the analogy to African form in the early 1980s by linking Gilliam's folding and staining processes to those of African textiles.[84]

Like his peers gathered here, Gilliam's commitment to aesthetic and material experimentation clearly did not prevent him from social engagement on some level, and like them too, though fascinated with what the entire universe had to offer, he never stepped away from being a black man in the world. In an interview in *Art News* in 1973, answering the proverbial question regarding "black art," Gilliam mused, "I think there has to be a black art because there is a white art ... Being black is a very important point of tension and self-discovery. To have a sense of self-acceptance we blacks have to throw off the dichotomy that has been forced on us by the white experience."[85] In a compelling reversal of the pejorative connotations some saw in the term, Gilliam further noted:

Even just the phrase *black art* is the best thing that has happened for the condition of black artists in America. It really calls attention to the number of major galleries in New York and museums around the world that had not shown, were not showing, were not *willing* to show any work by any black artist. Yet everyone has not come aboard, you *know* that. And there's that same kind of tokenism as before... But there is nothing to suggest in the history of men that we would ever arrive at utopia.[86]

In the works of Barbara Chase-Riboud from this era we find some of the most pointed meditations on beauty. For Chase-Riboud, this was a major function of life and there was a need for the important and expansive possibilities signaled by the notion of the beautiful in conjunction with that of blackness. In a moment when contemporary art in the U.S. was captivated by conceptualism, minimalism, process and things that generally celebrated the non-aesthetic object or anti-form, Chase-Riboud's focus on the aesthetic and the beautiful can be seen as diametrically opposed. Lyricism and romanticism in her work were identified by critics as having French sources, but I would argue that in another sense these aspects of her work epitomized the complexities of black artists' tendentious relationship to Western cultural canons.

In light of the negative and problematic reception of her first solo show at a commercial gallery in New York in 1970, it is not surprising that Chase-Riboud would never again make the U.S. her home, especially when her expatriate existence seemed to allow her talents to flourish. Her eloquent response to the situation appeared several months after the exhibition closed, in the second issue of the new black women's magazine, *Essence*. Getting right to the point, Chase-Riboud acknowledged that critics—Hilton Kramer, the chief art critic for *The New York Times* being a "typical" example—completely "misinterpreted" her work because she was black and a woman. Rather than setting out to make protest work with her exhibition *Four Monuments to Malcolm X*, the artist was "trying to express the ideas of a man who, more than any single individual, has affected the way Black people think of themselves. My aims were philosophical and moral." Chase-Riboud recognized that in "America today political art is necessary to the Black community," and even agreed that abstract art might be "out of place in a revolutionary situation." Yet she concluded, "My work may be too abstract or too sophisticated for revolutionary needs. I don't know. But it's too late for me to turn back."[87] She encouraged young African-American artists to travel, see the world as she had and break the confines of American existence and knowledge.

Jack Whitten described his semi-figurative work of the 1960s as a way to manage "the pressure of being a black in America. And keep in mind I'm not talking about some kind of intellectual choice here. This was psychological necessity. It's just there, and you have to work with it. You work with it or it works with you."[88] Later Whitten found that this reflexive urge need not cast itself as figurative, but could be manifested through experimentation with materials, modes of perception and thought.

Whitten participated in scant few exhibitions featuring solely black artists in the 1960s and 1970s and he still managed to show and sell his work.[89] As with Gilliam, this was not a rejection of the reality of his life as a black person, rather he saw himself as part of a larger world picture. Equally his identity as a person and a painter was quite specific. "For me being black has something to do with the making of the image. But it is also important that I am from the South, that I worked in the construction trade, that I am living in New York..."[90]

Whitten's (and Overstreet's and others') strong connection to Rivers' artistic example was perhaps due to their shared rural Southern roots; Whitten was originally from Alabama and Overstreet from Mississippi. As Whitten once commented, "you know what attracted me to painting in the first place and to art? Being in the South, where you're black and the white people own everything and you're always in the back, and you can't do anything until they say, 'You do this, you do that.' [Art instead represented] an amazing kind of freedom."[91] The creative act demonstrated the possibility of inventing worlds that one wanted, making them function and look the way one wanted, and the ability to own one's mind, one's thoughts, and make them matter, make them count in the world.

Afro-American Abstraction

In the spring of 1980 April Kingsley curated *Afro-American Abstraction* for New York's P.S.1 Institute for Art and Urban Resources. Like *Energy/Experimentation*, the exhibition was interested in combating the invisibility of black artists working non-objectively but also wanted to provide a broader historical context for this work. More than half of the artists included here participated in the earlier show.[92] Unlike 1960s and 1970s exhibitions of "black art," this one was thematically coherent, bringing together abstract art by African-American artists and its relationship to African aesthetics. In a sense this emphasis gave us a view of what was to come in the 1980s with the focus on identity-based work. The show was well-received, though critics were skeptical about the one-to-one relationship between the non-objective work on view and traditional African art. Even

Kingsley herself noted, "I became convinced that the pluralism of the 70s and the growing need for humanistic content and mythic and ritual significance in art offered optimum connections for Afro-American artists," hinting at a more expansive reading of the contextualization of this work.[93]

The artists in *Afro-American Abstraction* and in *Energy/Experimentation* worked in ways contemporary to their time. They were a part of the ongoing development of American abstraction; their aesthetics were inflected by minimalism but also, as the era progressed, embraced a more expansive array of art languages, identified by Kingsley as "pluralism of the 70s," and named post-minimalism by others.[94] This trend intervened in the cool impersonality associated with formalist abstraction and minimalism, rethinking ideas of content, emotion, expression and the eruption of conceptualism and performance. Post-minimalism offered important space for black artists because it allowed for the emergence of their positionality on a multiplicity of levels in terms of context and content. Previously, "race" was always spun as something "extra" and additional, particularly to formalist art-making; it was somehow unquantifiable in an abstract context even though these ideas had always been there. Speaking in 1973 of what black artists brought to the formalist table, Chase-Riboud coined the term "maximal," a notion certainly counterposed to minimalism and one that would be taken up briefly by mainstream criticism around 1980 to identify what would become known as post-modernism.[95]

Maximalism

"Maximal art," in Chase-Riboud's view, brought something extra to the table. As she commented, "I think our civilization is minimal enough without underlining it. Sculpture as a created object in space should enrich, not reflect, and should be beautiful. Beauty is function."[96]

The "maximal" on one hand described art that incorporated something that "functioned" in life, in the larger social world, even (or perhaps especially) on a metaphysical level, as both Chase-Riboud and Melvin Edwards insisted.[97] Other experiences, thoughts and notions of blackness, Diaspora, labor, culture and emotions were brought to and invested in contemporary art practice, which seemed to be uncontainable within the forms and language of post-painterly abstraction and minimalism. Concepts of beauty operated in this way for Chase-Riboud, and also for Alma Thomas and Al Loving, whose search for and recording of the beautiful was the energy that fueled the work. The "maximal" was exemplified in William T. Williams' and Loving's alternate takes on geometricism—emotional in

the former case and portraiture in the latter ("even a box can be a self-portrait," Loving noted [98]). It could be seen in Bowling's stain paintings that channeled the African Diaspora, for example, or in the sonic/visual dialogue so many of the artists had with avant-garde jazz in terms of compositional complexity and meditations on cultural identity. Finally, it could be seen in the way these artists refused to avoid race, their participation in some way in the social struggles of the time and their insistence that all this could exist with, and in, their non-objective work.

"Maximalism" also offered an explanation for a more heterogeneous sense of practice, such as Chase-Riboud's gathering of sources worldwide for her creative work as a sculptor, poet and novelist. Fred Eversley was trained as an electrical engineer and it was his family business; over the years he continued to work on and off as a consultant in the field. Eversley's presence begs a question: does his multiple positions as black person, engineer and artist, whose work represented the intersection of aesthetics and scientific properties, modulate our thinking about the place and importance of this work?

This idea of heterogeneity also provided space for notions of the African Diaspora. It was not necessarily a direct link with Africa, as Kingsley attempted to argue, but a connection to how African culture impacted the world. Chase-Riboud's projects ponder sites all over the globe—thus her admonition for young artists of color to study and embrace global aesthetics. Edwards also recounted the importance of creative inspiration from Guyana, Cuba, Ghana and Egypt during this period. We see it in Pindell's series on Iemanja, an Afro-Brazilian goddess. And this notion even erupts in Chase-Riboud, Clark and Rivers' relationships to Paris, an outpost of the African Diaspora at least since the New Negro and Negritude movements of the 1920s and 1930s. Similarly, Frank Bowling's recurring invocation of "experience," and particularly that which took into account the global reaches of black culture, in his criticism in the 1960s and 1970s, articulated the same concept. These were the beginnings of a discourse that would challenge the monologic viewpoint of Western art history at the end of the 20th century and into the new millennium.

Endnotes

1 *Since the Harlem Renaissance: 50 Years of Afro-American Art* (Lewisburg, PA: The Center Gallery at Bucknell University, 1984) 21. For more information on the shared camaraderie and exhibitions of Gilliam, Edwards and Williams, see: Mary Schmidt Campbell, "Sam Gilliam: Journey Toward Red, Black, and 'D'," *Red & Black to 'D': Paintings by Sam Gilliam* (New York: The Studio Museum in Harlem, 1982) 9; Jonathan Binstock, *Sam Gilliam* (Washington, D.C.: Corcoran Gallery of Art, 2005).

2 Mary Schmidt Campbell, "Sam Gilliam: Journey Toward Red, Black, and 'D'," *Red and Black to D: Paintings by Sam Gilliam* (New York: The Studio Museum in Harlem, 1982) 9.

3 Al Loving's show that opened in December 1969 would be the first of 12 exhibitions the Whitney would do with black artists over the next six years. Almost all of them were curated by then Associate Curator Marcia Tucker, who would go on to found The New Museum of Contemporary Art in 1977. Alma Thomas's show opened in April 1972. See: Kellie Jones, "It's Not Enough to Say 'Black is Beautiful' Abstraction at the Whitney 1969-1974," *Discrepant Abstractions*, ed. Kobena Mercer (Cambridge: The MIT Press, 2006).

4 Rivers' thick canvases and Clark's shaped paintings have also been ascribed to the reuse of materials due to lack of funds. See: Kellie Jones, *Abstract Expressionism: The Missing Link* (brochure) (New York: Jamaica Arts Center, 1989).

5 Judith Wilson, "How the Invisible Woman Got Herself on the Cultural Map," *Art/Women/California: Parallels and Intersections, 1950-2000*, eds. Diana Burgess Fuller and Daniela Salvioni (San Jose: San Jose Museum of Art, 2002) 201-216.

6 Eleanor Munro, "The Late Springtime of Alma Thomas," *The Washington Post Magazine* 15 April 1979: 18-24. On the garden as vernacular creativity, see the title essay in: Alice Walker, *In Search of Our Mothers' Gardens* (San Diego: Harcourt Brace & Co., 1983).

7 Walter Robinson, "Al Loving at William Zierler," *Art in America* (Sept.-Oct. 1973): 110.

8 *Since the Harlem Renaissance* 33.

9 David C. Driskell, "...and unending visual odyssey" *William T. Williams* (Winston-Salem: Southeastern Center for Contemporary Arts, 1985):43.

10 *Since the Harlem Renaissance* 47.

11 *Since the Harlem Renaissance* 47.

12 April Kingsley, "From Explosion to Implosion: The Ten Year Transition of Williams T. Williams," *Arts* 55 (February 1981):154.

13 Munro, *The Washington Post Magazine* 24.

14 Munro, *The Washington Post Magazine* 24.

15 Peter Plagens, *Sunshine Muse, Art on the West Coast, 1945-1970* (New York: Praeger, 1974) 120.

16 Walter Hopps and Nina Felshin Osnos, "Three Washington Artists: Gilliam, Krebs, McGowin," *Art International* (May 1970): 32.

17 Hopps and Osnos 33.

18 Jay Kloner argues that Gilliam devised three basic "modes of presentation: hanging close to the wall, extending out from the wall but retaining a proximity, and projecting into the space of a room." See: Jay Kloner, "Sam Gilliam: Recent Black Paintings," *Arts Magazine* (Feb. 1978): 150-153. Also see: Hopps and Osnos 34 and Jonathan Binstock, *Sam Gilliam* (Washington, D.C.: Corcoran Gallery of Art, 2005) 62-63.

19 Overstreet's solo show at The Studio Museum was paired with another of sculpture by Ben Jones.

20 John Canaday, "Art: Scanning America of the 19th Century," *The New York Times* 1 Nov. 1969; Frank Bowling, "Joe Overstreet," *Arts Magazine* (Dec. 1969): 55.

21 Frank Bowling, "Joe Overstreet," *Arts Magazine* (Dec. 1969): 55.

22 Edward S. Spriggs, *Ben Jones and Joe Overstreet* (New York: The Studio Museum in Harlem, 1969) n. pag.

23 Overstreet talks about conceiving these works as types of portraits after the example of African masks. See: Spriggs n. pag.

24 Judith Wilson and Lizetta LeFalle Collins, *Sargent Johnson: African American Modernist* (San Francisco: San Francisco Museum of Modern Art, 1998).

25 While the colors of the piece appear to be red, black and green, the artist referred to the deepest tone as a very deep purple when I visited. Personal communication, 24 Feb. 2006.

26 *Joe Overstreet: Works From 1957 to 1993* (Trenton: New Jersey State Museum, 1996). It is interesting to think of these pieces as being made by Overstreet in the Bay Area. It was a place that he came to know as home, but only after his family had crisscrossed the country during his childhood years and finally settled in Berkeley in 1946. Overstreet also sailed with the Merchant Marine between 1951 and 1958; the proficiency with rope in these pieces may owe something to this experience.

27 Mary Schmidt Campbell, "Introduction," *Melvin Edwards, Sculptor* (New York: The Studio Museum in Harlem, 1978) 3-10.

28 Chase-Riboud's writings such as *Sally Hemmings* (1979) and *The President's Daughter* (1994) brought to life Thomas Jefferson's black mistress long before the DNA tests confirmed that the president was involved in the same type of liaison that formed the making of America. Many of her works also foreground

women's history, such as her meditations on Cleopatra in poetry, *Portrait of a Nude Woman as Cleopatra* (1988) and a suite of impressive sculptural objects made between the 1970s and 1990s, including *Le Manteau (The Cape)* (1973) in the collection of The Studio Museum in Harlem. Chase-Riboud's most recent novel, *Hottentot Venus* (2003) was proceeded by the sculpture Sarah Baartman/Africa Rising (1996). See: Lisa Jones, "A Most Dangerous Woman," *The Village Voice* 3-9 Feb. 1999.

29 Françoise Nora, "From Another Country," *Art News* (March 1972).

30 Eleanor Munro, *The Originals: American Women Artists* (New York: Macmillan, 1979) 370-376.

31 *Since the Harlem Renaissance* 44.

32 Henry Geldzahler, "Jack Whitten: Ten Years-1970-1980," *Jack Whitten: Ten Years-1970-1980* (New York: The Studio Museum in Harlem, 1983) 8. Geldzahler also makes a link between Whitten's ideas and those of Sam Gilliam around this time. He quotes Mary Schimdt Campbell on the artist, "Gilliam's cascades of color are not unlike Coltrane's sheets of sound." Mary Schmidt Campbell, "Sam Gilliam: Journey Toward Red, Black, and 'D'," *Red & Black to 'D': Paintings by Sam Gilliam* (New York: The Studio Museum in Harlem, 1982) 9. Whitten himself played tenor saxophone in college. *Since the Harlem Renaissance* 45.

33 Kellie Jones, "Chronology," *Jack Whitten: Ten Years-1970-1980* (New York: The Studio Museum in Harlem, 1983) 15.

34 Corrine Robins, "Edward Clark," *Arts* (October 1975): 8.

35 Janey Washburn, "Bill Hayward [sic] Rivers, Painter, April 21, 1985," *Artists and Influence* (1986): 99.

36 Ann Gibson, "Two Worlds: African-American Abstraction in New York at Mid-Century," *The Search for Freedom: African American Abstract Painting, 1945-1975* (New York: Kenkeleba Gallery, 1991) 20.

37 Washburn 96

38 John Tancock, "Frank Bowling at the Center for Inter-American Relations," *Arts Magazine* 48 (Dec. 1973): 58.

39 Kobena Mercer, "Frank Bowling's Map Paintings," *Fault Lines: Contemporary African Art and Shifting Landscapes*, eds. Gilane Tawadros and Sarah Campbell (London: Institute of International Visual Arts 2003) 141.

40 Mercer 146-147.

41 Carrie Ricky, "Howardena Pindell," *The Village Voice* 23 April 1980: 79.

42 Judith Wilson, "Private Commentary Goes Public," *The Village Voice* 15 April 1981: 84.

43 Judith Wilson, "Howardena Pindell Makes

Art that Winks at You," *Ms. Magazine* May 1980: 70.

44 *Since the Harlem Renaissance* 44.

45 Donald Miller, "Three-Woman Art Show," *Pittsburgh Post Gazette* 13 May 1975.

46 For a definition of Afro-Futurism, see: "Afrofuturism Special Issue," ed. Alondra Nelson, *Social Text* 71 (Summer 2002).

47 Barbara Chase-Riboud and Françoise Nora, "Dialogue: Another Country," *Chase-Riboud* (Berkeley: University Art Museum, 1973) n. pag.

48 Thanks to my colleague, Alondra Nelson, for calling my attention to this. Personal communication, March 2005.

49 David C. Driskell, "Foreword," *Alma W. Thomas Recent Paintings, October 10--Novemenber 12, 1971* (Nashville: Carl Van Vechten Gallery of the Fine Arts, Fisk University, 1971).

50 David L. Shirey, "At 77, She's Made It to the Whitney," *The New York Times* 4 May 1972: 52.

51 Munro, *The Washington Post Magazine* 24.

52 Henri Ghent, "Notes to the Young Black Artist: Revolution or Evolution," *Art International* (20 June 1971): 33.

53 However, the majority of artists chosen for that show remained, including Al Loving, Frank Bowling, Alma Thomas and Barbara Chase-Riboud. "Politics," *Artforum* 9 (May 1971): 12; Grace Glueck, "15 of 75 Black Artists Leave As Whitney Exhibition Opens," *The New York Times* 6 April 1971: 50. Romare Bearden pulled his work from the show after it had already been installed. For a further discussion of this exhibition, see: Kellie Jones, "It's Not Enough to Say 'Black is Beautiful' Abstraction at the Whitney 1969-1974," *Discrepant Abstractions*, ed. Kobena Mercer (Cambridge: The MIT Press, 2006).

54 Local teenagers were hired to complete ground-level painting. After a while, these same groups made their own non-representational murals or rechristened fire hydrants in similar hues. In other instances, paint vanished from projects and was used by people to transform their own living spaces. Michael Oren, "The Smokehouse Painters, 1968-1970," *Black American Literature Forum* 24:3 (1990): 512, 516.

55 Grace Glueck, "Less Downtown Uptown," *The New York Times* 20 July 1969: D19-20

56 The museum's first director, Charles Inniss, resigned after six months and resumed his career in the corporate world. The museum's board, initially composed of heavy hitters from the mainstream art world, was "white-weighted" and strong in people identified with the Museum of Modern Art, including Kynaston McShine, then an Associate Curator there. A newly constructed board a few months later included James Hinton of Harlem

Audio visual Productions and Charles Hobson, writer-producer with WABC-TV's "Like It Is," an early African-American television talk show hosted by Gil Noble. It is interesting to see how some of this initial black representation on the museum board came from the media rather than the art world. The focus on film that was an early aspect of the museum's profile represented at once the lack of black people in administrative positions in the art world and how media was seen as the cutting edge at that moment. Glueck, "Less Downtown Uptown" D19.

57 Glueck, "Less Downtown Uptown" D19.
58 Grace Glueck, "Harlem Initiates First Art Museum," *The New York Times* 27 September 1968; Jonathan Binstock, *Sam Gilliam* (Washington, D.C.: Corcoran Gallery of Art, 2005) 62-63.
59 *Store Front Museum/Paul Robeson Theater, A Community Museum in the Inner City, 10th Anniversary Publication* (New York: Store Front Museum, 1981).
60 Francis Frascina, *Art, Politics, and Dissent* (New York: St. Martin's Press, 1999). In 2006 the Whitney Museum of American Art is revisiting the Peace Tower structure as part of the Biennial exhibition.
61 For a discussion of this statement and the show, see: Kellie Jones, "It's Not Enough to Say 'Black is Beautiful' Abstraction at the Whitney 1969-1974," *Discrepant Abstractions*, ed. Kobena Mercer (Cambridge: The MIT Press, 2006).
62 Melvin Edwards, "Notes on Black Art," *Melvin Edwards, Sculptor* (New York: The Studio Museum in Harlem, 1978) 20.
63 Edwards 20.
64 These protests were organized by the Black Emergency Cultural Coalition.
65 *Since the Harlem Renaissance* 30.
66 *Since the Harlem Renaissance* 30.
67 Ghent 33.
68 It appears that Pindell also was the one who named the co-op. A-I-R stood for "artists in residence," but was also a pun on Jane Eyre, the Charlotte Bronte heroine. See: Wilson, *Ms. Magazine* 69.
69 Howardena Pindell, "Free White and 21," *The Heart of the Question: The Writings and Paintings of Howardena Pindell* (New York: Midmarch Arts Press, 1997) 65-69.
70 Richard Goldstein, "Darky Chic," *The Village Voice* 31 March 1980: 34; Wilson, *Ms. Magazine* 70. It is interesting to think about the "Nigger Drawings" in conjunction with contemporaneous "investigations" of blackface by white artists, including early photographs by Cindy Sherman, Eleanor Antin's performances as Antinova, a black

Russian ballerina, and the Wooster Group's theater piece *Route 1 & 9*.
71 Howardena Pindell, "Art World Racism: A Documentation," *New Art Examiner* 16:17 (March 1989): 32-36; Pindell, *The Heart of the Question*.
72 Kellie Jones, *Abstract Expressionism: The Missing Link* (brochure) (New York: Jamaica Arts Center, 1989).
73 Washburn 102.
74 *Joe Overstreet* 22.
75 Julie Ault ed., *Alternative New York, 1965-1985* (Minneapolis: University of Minnesota Press, 2002).
76 The six articles were: "Discussion on Black Art," *Arts Magazine* 43 (April 1969): 16, 18, 20; "Discussion on Black Art II" *Arts Magazine* (May 1969): 20-23; "Black Art III" *Arts Magazine* 44 (Dec. 1969-Jan. 1970): 20, 22; "The Rupture: Ancestor Worship, Revival, Confusion, or Disguise" *Arts Magazine* 44 (Summer 1970): 31-34; "Silence: People Die Crying When They Should Love," *Arts Magazine* 45 (Sept. 1970): 31-32; "It's Not Enough To Say 'Black Is Beautiful'," *Art News* 70 (April 1971): 53-55, 82-84. Also see: Kellie Jones, "It's Not Enough to Say 'Black is Beautiful' Abstraction at the Whitney 1969-1974," *Discrepant Abstractions*, ed. Kobena Mercer (Cambridge: The MIT Press, 2006).
77 Munro, *The Washington Post Magazine* 24.
78 Munro, *The Washington Post Magazine* 23.
79 H.E. Mahal, "Interviews: Four Afro-American Artists," *Art Gallery* (April 1970): 36-37.
80 Munro, *The Washington Post Magazine* 23.
81 Excerpts from these two statements can be found in: Anita Feldman, "A Complex Identity: Edward Clark, 'Noir de Grand Talent'," *Edward Clark* (New York: The Studio Museum in Harlem, 1980) n. pag.
82 One canvas from this series, *April 4, 1969*, is in the collection of The Studio Museum in Harlem.
83 The piece was also influenced by his wife's, Dorothy Gilliam's, work on a biography of Robeson. See: Mary Schmidt Campbell, "Sam Gilliam: Journey Toward Red, Black, and 'D'," *Red & Black to 'D': Paintings by Sam Gilliam* (New York: The Studio Museum in Harlem, 1982) 6, 9.
84 LeGrace Benson, "Sam Gilliam: Certain Attitudes," *Artforum* (Sept. 1970): 58; Mary Schmidt Campbell, "Sam Gilliam: Journey Toward Red, Black, and 'D'," *Red & Black to 'D': Paintings by Sam Gilliam* (New York: The Studio Museum in Harlem, 1982) 6.
85 Donald Miller, "Hanging Loose: an interview with Sam Gilliam," *Art News* (Jan.

1973): 43.
86 Miller, *Art News* 43.
87 "People - Barbara Chase-Riboud," *Essence* 1:2 (June 1970): 62, 71. Chase-Riboud also received at least one positive review of her 1970 Bertha Schaefer exhibition. Kramer's comments also generated some interesting letters in support of the artist's work. See: M.L., "Barbara Chase-Riboud," *Art News* (March 1970): 12; Henri Ghent and Alvin Smith, "Art Mailbag," *The New York Times* 19 April 1970: 22. Some of the problematic reviews Chase-Riboud responded to included: Hilton Kramer, "Black Experience and Modernist Art," *The New York Times* 14 February 1970: 23 and Gerrit Henry, "New York" *Art International* (May 1972): 54.
88 *Since the Harlem Renaissance* 43.
89 Whitten did participate in the exhibition *In Honor of Dr. Martin Luther King, Jr.* at the Museum of Modern Art in 1968.
90 *Since the Harlem Renaissance* 46.
91 Beryl J. Wright, *Jack Whitten* (Newark: The Newark Museum, 1990) 12-13.
92 Included were Clark, Edwards, Gilliam, Loving, Pindell, Whitten and Williams. Chase-Riboud appeared at P.S.1 but was not a part of the exhibition tour, which took place between 1982 and 1984.
93 April Kingsley, *Afro American Abstraction* (San Francisco: The Art Museum Association, 1982) n. pag.
94 Robert Pincus-Witten, *Postminimalism* (New York: Out of London Press, 1977).
95 Robert Pincus-Witten, *Entries (Maximalism)* (New York: Out of London Press, 1983).
96 Chase-Riboud and Nora n. pag.
97 Edwards.
98 Frank Bowling, "It's Not Enough To Say 'Black Is Beautiful'" *Art News* 70 (April 1971): 83.

Frank Bowling
Bartica Born III, 1969
Acrylic on canvas
114 x 54 inches
Courtesy of the artist
Photo: Joe Grant

Frank Bowling
Barticaflats Even Time, 1980
Acrylic and oil on canvas
28 x 78 inches
Collection of The Metropolitan
Museum of Art, Gift of Dr. and Mrs.
Robert E. Carroll, 1981 (1981.509)
Photograph © 2006 The Metropolitan
Museum of Art

Ed Clark
Untitled, 1974
Color etching on paper
22 x 30 inches
Collection of The Studio
Museum in Harlem,
Anonymous Gift, 00.3.3

Ed Clark
Yucatan Series, 1977
Acrylic on canvas
45 1/2 x 63 inches
Courtesy of the artist
Photo: Marc Bernier

Melvin Edwards
Cotton Hangup, 1966
26 x 30 x 20 inches
Welded steel
Collection of The Studio Museum
in Harlem, Gift of Mr. and Mrs.
Hans Burkhardt, 91.21

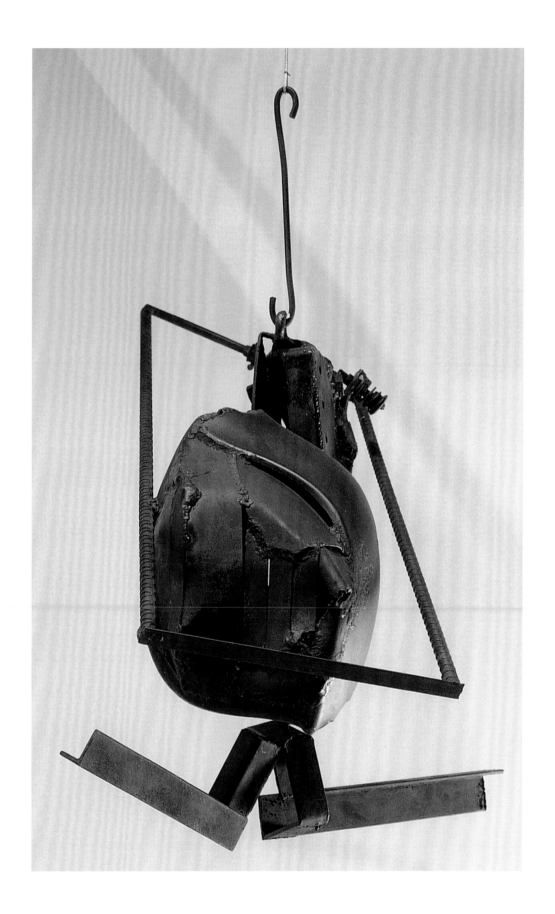

Melvin Edwards
The Lifted X, 1965
Welded steel
65 x 45 x 22 inches
Courtesy of the artist
Photo: Marc Bernier

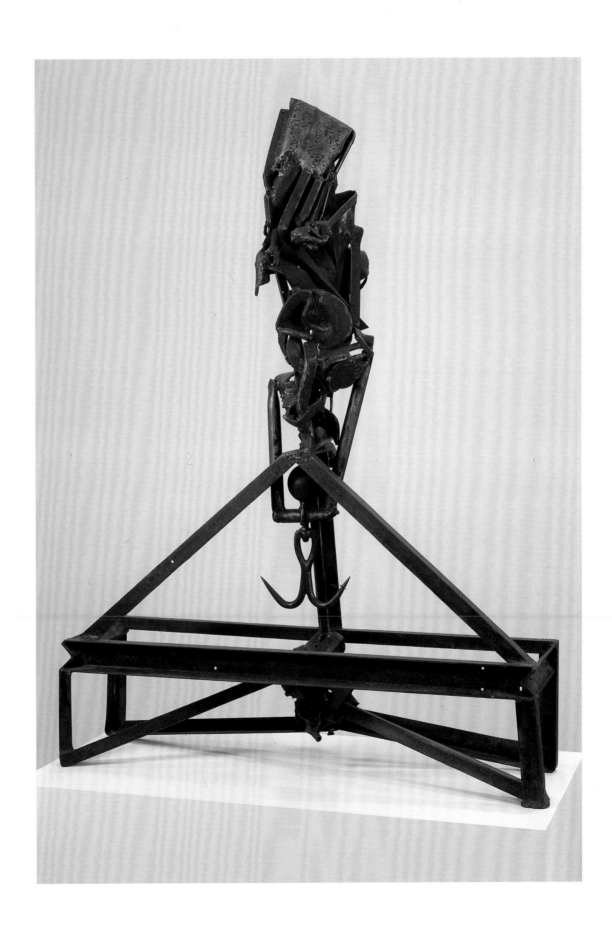

Discrete Encounters: A Personal Recollection of the Black Art Scene of the 1970s

Lowery Stokes Sims

Discrete Encounters: A Personal Recollection of the Black Art Scene of the 1970s

Lowery Stokes Sims

Flashback: 1979

I give you a photograph. [fig. 1] In it, Studio Museum trustee Gordon Davis, then Commissioner of Parks for the City of New York, and me, Studio Museum President Lowery Stokes Sims, then Associate Curator of 20th-Century Art at The Metropolitan Museum of Art (MMA), are in the company of artists Avel deKnight and Alvin Loving. The year was 1979, and at the request of then Commissioner Davis I had organized an exhibition of African-American artists from the collection of the MMA at the Parks Department offices in the Arsenal at 64th Street and Fifth Avenue on the edge of Central Park. This was the second time I had organized an exhibition of African-American artists from the MMA's collection. The first time was in 1976 for the Bedford Stuyvesant Restoration Corporation. That project resulted in my first lesson in institutional politics.

I wrote an essay to accompany the 1976 exhibition that, in hindsight, was a rather pointed analysis of the social, political and economic aspects of institutional collecting of the work of black artists. It was blunt and honest and the analysis was precise, but it was deemed too political and rejected for the publication. I'm not sure if it was my call for an "art interest lobby" for black artists by black people that seemed too radical then, when the MMA had just come through the turmoil surrounding the *Harlem on My Mind* exhibition of 1969–70, or if it was the naïveté of youth that torpedoed that effort, but in 1979

I worked with the support of a Commissioner who could have some say—"yea" or "nay"—on MMA projects in and around the Park. So that time things went a bit smoother. Until, that is, a reporter from NBC covering the event looked me in the eye after surveying the exhibition and pronounced innocently, "Gee! I didn't know there were black artists!"

Encounter # 1: Harlem on My Mind

In the beginning it was never about "figurative" versus "abstract." It was about getting recognition for black artists in mainstream American and world art. At least that was my experience when I majored in art history at Queens College in the 1960s (1966-1970) and complained about the absence of black artists from the curricula of courses on American or modern art. The rather patronizing response I always got was that black art was "retarditaire," or "social realist protest art." My riposte, that such opinions were obviated by the social conditions of the time, fell on deaf ears. This was, after all, the age of formalism, when art was, in the deadpan words of Irving Sandler, focusing on technique over content.[1] As Robert Colescott has noted, however, for black American artists, "the image is never incidental." [2]

In the context of the civil rights (and by then Black Power) movement, many in the black community felt that the stakes were too high to leave the matter of art to chance. When the MMA organized a symposium to discuss the situation of the black artist in America in

1 Irving Sandler, "The New Cool Art," *Art in America* Jan. 1965: 96-101.
2 Ann Shengold, "Conversation with Robert Colescott," *Robert Colescott: Another Judgment* (exhibition catalogue), ed. Kenneth Baker (Charlotte, N.C.: Knight Gallery/ Spirit Square Arts Center, 1985) n.pag.

Fig 1

3 "The Black Artist in America: A Symposium," *The Metropolitan Museum of Art Bulletin* XXVII, 5, Jan. 1969: 245-260.
4 April Kingsley, *Afro-American Abstraction* (exhibition catalogue) (Long Island City: P.S.1, 1980).
5 David Craven, "Norman Lewis as Political Activist and Post-Colonial Artist," *Norman Lewis: Black Paintings, 1946–1977* (exhibition catalogue) (New York: The Studio Museum in Harlem, 1998) 53.
6 To this day, the Queens College website has this notation on this program: "The Search for Education, Elevation, and Knowledge (SEEK) program serves academically underprepared and economically disadvantaged students who would not otherwise qualify for admission. SEEK helps students achieve academic success by providing financial support, academic instruction, tutorial assistance, and counseling services. More information is available in the Operation SEEK Student Handbook, obtainable from the office of the Director of the SEEK Program."
7 Benny Andrews, "Benny Andrews Journal: A Black Artist's View of Artistic and Political Activism, 1963-1973," *Tradition and Conflict: Images of a Turbulent Decade, 1963–1973* (exhibition catalogue), ed. Mary Schmidt Campbell (New York: The Studio Museum in Harlem, 1985) 69-73.

conjunction with the *Harlem on My Mind* exhibition, the participants were for the most part abstractionists, including Sam Gilliam, Tom Lloyd, William T. Williams and Hale Woodruff, or abstract figural painters, such as Romare Bearden and Jacob Lawrence. They had to discuss not only the role of the black artist in the community, but also what kind of art was appropriate for black artists to make. [3] It led to many articles on the nature of the art made by black people, but it was often missed that one of the sources of modernist abstraction was African art, so abstraction could—more than realism—constitute the quintessential black art. April Kingsley would finally give this idea a go in 1980 when she organized the exhibition *Afro-American Abstraction* at P.S.1 in Queens. [4]

Although I didn't attend the MMA symposium, I did see the exhibition, and right away I grasped the problem: it was a photo-documentary exhibition on Harlem, not an exhibition of work by artists in Harlem. There were lots of meetings and more than a few demonstrations about this: the SMH catalogue for its 1998 Norman Lewis exhibition included a photograph of him [fig. 2] demonstrating in front of the MMA with a placard that read, "That's white of Hoving." [5] As a result of these demonstrations, the MMA instituted the Community Programs Department under the directorship of Susan Coppello (later Badder), who hired me in 1972. [fig. 3] After she left, Cathy Chance took over and became perhaps the first black administrator in the MMA's history. I eventually had access to the files on *Harlem on My Mind* and could see that the miscommunication about the content of the exhibition existed from the beginning.

Encounter #2: Benny Andrews

When I was an undergraduate at Queens College in 1967, I got a job tutoring for the new remedial program, SEEK (Search for Education, Elevation and Knowledge). [6] I was hired to tutor entering students in art history, and that is how I met Benny Andrews, [fig. 4] the art instructor working with the program. He subsequently became an inescapable part of my life. It was through Benny that I learned the intricacies of the politics of museums and first entered the Tombs, the notorious prison in lower Manhattan, to observe an art workshop organized by the Black Emergency Cultural Coalition. Later I was implicated in his censure of the MMA's community exhibition program. The exhibition spaces allotted to that program were located on a wall at the 81st Street entrance and in the former Junior Museum cafeteria. Since I was in charge of that program at that time, I tried not to take his criticism personally.

Benny was the point-person for much of the agitation against mainstream museums in the 1970s on behalf of black artists. Excerpts from his journals published in the catalogue for the SMH's 1985 exhibition, *Tradition and Conflict: Images of a Turbulent Decade, 1963-1973*, chronicle demonstrations, press events and meetings with museum officials between 1968 and 1973, including the group effort to secure the participation of black scholars in the organization of *Harlem on My Mind*, and to negotiate greater involvement of black artists with the Whitney Museum of American Art through acquisitions, the annual exhibition and the hiring of black professional staff. [7] He also wrote of his involvement in demonstrations against the Vietnam War, the publication of the books he coordinated with Rudolph Baranik on the uprising in Attica prison and organizing an art workshop for inmates at the Manhattan House of Detention (the aforementioned "Tombs"). The journal ends rather triumphantly with him attending the exhibition *Blacks: USA, 1973*, at the New York Cultural Center. This exhibition was curated by an all-black selection committee.

Encounter #3: Ma Nuit Chez Frank (Avec Dana)

Okay, so far the pressing issues were representation of black creativity in mainstream

Fig 2 Photo: Jack Manning, *The New York Times*

Fig 3

Fig 4

Fig 5

museums, the presence of black professionals to steward the interests of black artists in institutions, the problematic status of "community" galleries and the role of black artists as good citizens in those contentious times. The specifics of the abstract/figurative dichotomy came home to me one February evening in 1974 during the annual conference of the College Art Association (CAA), which was being held in New York that year. I found myself in the company of Dana Chandler, wending my way to Frank Bowling's studio on Seventh Avenue, not far from the Hilton, where the CAA conference always occurs when in the city. Frank was ensconced there with his companion at the time, writer Lucienne Wolf. As the evening progressed, the antagonism between Dana and Frank increased and the source of contention was what or who constituted a "black artist."

According to Dana—and I paraphrase here according to my memory—if an artist was black, then he or she did black art, and their mission was to cast the black image against stereotypes and create images of an idealized black nation. These would be both sentimental and confrontational in nature. Frank, who had published several thoughtful pieces on the issue of black art in *Arts Magazine*,[8] rejected such ideas, which in his view not only reinforced stereotypes about African-American artists, but also limited their options in the art world. For Frank, one's color was incidental, as most black artists had the same artistic training in the same institutions, and shared a social experience and frame of reference, with non-black artists, obviating color characteristics. However well-reasoned Frank's argument was, Dana never relented that night, and his indictment of black artists who did abstract art would resonate for years to come.

Encounter #4: Howardena Pindell's Postcards From the Edge

At this time I also became friends with Howardena Pindell. When we met in 1973, she was a curator in the Drawings and Print Department at the Museum of Modern Art. Almost immediately after that, we had the opportunity to travel together to Africa on grants provided by our respective museums. Our itinerary took us to Nairobi by way of London, Nigeria, Ghana, the Ivory Coast and Senegal. [fig. 5] When we returned, I frequented her studio on Seventh Avenue and 28th Street and watched her paint her intricate canvases, which she tore into strips and sewed back together, and punch out millions of dots from colored papers with hole punches. She then used the templates left by this process to squeeze paint onto the canvas in globs like toothpaste. Occasionally she let me squeeze some paint or drop some dots or glitter onto a work in progress.

Howardena showed me the fungible nature of the "Blackstream" and "mainstream" categories through the development of her career, which responded powerfully and cogently to phenomena in her own life. Writing about her career in 1992, I described developments in her work after our trip to Africa: "Up to that time, Pindell remembers, the principle referent for her work was the elliptical imagery of Larry Poons. But it was clear by the mid-1970s that she was doing something quite distinct from optical abstraction. Pindell had also been a founding member of the women's cooperative A.I.R. in the early 1970s, so it was easy to read these works as Pindell's manipulation of the language of minimalism and formalism to a womanist interest."[9]

In addition to feminist concerns, Howardena's long-time fascination with African art and its textural nuances—so aptly reflected in her own accumulative surfaces and tendency to free the canvas from the stretcher so that it existed in space like textiles—brought me inevitably back to the African origins of abstraction. Later, as she created her Jiri Kolar-like fan-shaped collages from postcards collected on subsequent trips to India and Japan—attempts to jog a memory impaired in an automobile accident—her innate skill in abstraction meshed with the inherent figural elements of her mate-

8 "Black Art," Dec. 1969–Jan. 1970: 20-23; "Discussion on Black Art," April 1969: 16-20, May 1969: 20-23; "It's Not Enough to Say 'Black is Beautiful,'" April 1971: 53-55, 82.
9 Lowery Stokes Sims, "Synthesis and Integration in the Work of Howardena Pindell, 1972–1992," *Howardena Pindell: Paintings and Drawings* (exhibition catalogue) (Potsdam: Roland Gibson Gallery, Potsdam College of the State University of New York in association with Exhibits USA, 1992) 14-15.

10 Linda Goode Bryant and Marcy S. Philips, *Contextures* (New York: Just Above Midtown, Inc., 1978) 39.

rials in a way that obviated the distinction. She would go on to create polemical figural works that transcended the literal through her consummate skill as an abstractionist.

Encounter #5: Linda Goode Bryant and Just Above Midtown Gallery

In 1973, a young black woman came to work in the Photograph and Slide Library at the MMA. That is how Linda Goode Bryant entered my life. She was a young mother of two infants and had left a dissatisfying marriage in Atlanta to move to New York. The only things greater than her lack of resources were her drive and ambition. Within two years, Linda had corralled around her a cohort of friends and associates (including myself; Florence Heartney, who worked with me in Community Programs at the MMA; Faith Weaver, a young mother, graduate student and, like Linda, native of Columbus, Ohio; and Pat Cummings, an artist and book illustrator) who helped her realize her dream of a gallery on 57th Street featuring predominantly black artists. Because she had originally conceived of an upper Broadway location, the gallery was to be called Just Above Midtown Gallery (JAM).

From the beginning, the aesthetic predilections of the gallery were abstract and cutting edge. Linda, a group of friends and I had just spent time in Los Angeles (my first trip), during which time we met David Hammons, Suzanne Jackson and Dan Concholar, who would become the stars of the beginning years of the gallery. Their involvement in the gallery also led Hammons and Concholar to move to the East Coast. The exhibitions at JAM were varied: from Norman Lewis to Palmer Hayden. The gallery soon became the focal point of the black art scene in New York City, and by the late 1970s, Linda became a pioneer in Tribeca when she moved JAM to Franklin Street.

By then the focus of the gallery would be codified in Linda's collaborative publication with Marcy Philips, *Contextures*, which presented a new theoretical context for the work of black artists. From a discussion of the work of black artists working abstractly, Linda and Marcy progressed to *Contexture*, a neo-Dadaist manifestation in which "the process, materials, artist and art object interchangeably become the prominent elements of content and intent." [10] This provided an important context for artists like Hammons and anticipated the burgeoning installation and performance work by black artists that would blossom fully in the 1980s.

Encounter #6: Al Loving and Monet's Water Lilies

I don't remember exactly when I met Al Loving, fig. 6 but he certainly was a legend by the time I did. News of his 1969 exhibition at the Whitney buzzed through the press and across the East River to where I attended Queens College. It was a counterpoint from the art establishment to the complaints of the coalitions of black artists about their exclusion from mainstream art museums. But I think I really got to know Al through my friend Daisy Voigt. Daisy and I met when Courtney Callender, then director of The Studio Museum in Harlem, hired her to do press relations for *Living Space*, the exhibition on public housing that I organized at SMH in 1977. Daisy then continued as a public relations consultant, and the high point of her tenure at SMH was in 1979, when she convinced Hilton Kramer to review a joint exhibition there of the work of Al Loving and Howardena Pindell. It was the first review without the political acrimony that had characterized earlier press relations with SMH.

At about the same time, Al engaged me in conversation after he viewed the 1978 Monet exhibition at the MMA. I remember visiting one of his myriad studios around the city and being shocked at seeing what was tantamount to a landscape painting that he'd created in response to Monet. We discussed at length his desire to encompass the essence of Monet's work within an abstract format. Rather quickly afterward he created his water lily paintings,

Fig 6 Al Loving (1935–2005). Courtesy of Alicia Loving-Cortes and Anne Bethel

11 Lowery Stokes Sims, "The African-American Artist and Abstraction," *Norman Lewis: Black Paintings, 1946-1977* (New York: The Studio Museum in Harlem, 1998) 46-47.
12 Joseph Jacobs, *Since the Harlem Renaissance: 50 Years of Afro-American Art* (exhibition catalogue) (Lewisburg, PA: The Center Gallery, Bucknell University, 1984) 21.

All images courtesy of Lowery Stokes Sims, except where noted.

subjects that suggested the long-standing visual motif for his work: spiraling patterns of water in contact with falling elements and the floating forms of water lily pads. Like Monet did in his late paintings, Al eliminated the horizon line and collaged varicolored strips onto the canvas or paper in repetitive arcing patterns that suggested the arc of the ripples while conforming to the tenets of pattern and decoration, as well the minimalist sensibility that initially characterized his paintings.

Over the next few years, Al experimented with torn and sewn fabric and paper, handmade paper and monotypes. He eventually came to work exclusively on paper. Although we argued about his decision to mount paper on Plexiglas shapes and shellac the surface—his solution for eliminating the glass usually required to protect paper—the spiral form of his water lily paintings persisted in his work. In his last major exhibition in New York, Al created a dizzying, virtuoso display of swirls and curlicues with spatial effects, bold color and lots of patterns. It was a *tour de force*.

Hindsight Is Never 20/20

The observation of the television reporter I noted at the outset was all the more galling because of what had already gone on during the 1970s. Exhibitions of black artists, both figurative and abstract, or only figurative or only abstract, had proliferated all over the United States. Newspapers had been full of articles, even outside the art pages, on the debate about segregating black artists in all-inclusive exhibitions and the responses of institutions to demands for full equity in exhibition and acquisition programs. But what is most interesting in the period is that the line between figuration and abstraction was never as definitely drawn as even the protagonists of the time believed.

I noted, in writing about Norman Lewis, that in hindsight one could surmise the presence of Western modernism, as well as African decorative impulses, in the "futuristic explosion of color particles in Nelson Sevens' work

and the geometric patterning characteristic of Jeff Donaldson's Trans-Africanist painting." [11] Likewise, Frank Bowling achieved a proto-postmodern deconstruction of Colorfield painting by stenciling the outlines of South America or Africa onto his lush surfaces. It was Sam Gilliam who noted that "figurative art doesn't represent blackness any more than a non-narrative, media-oriented kind of painting." For Sam, what is important is that any artist's work deals with "metaphors that are heraldic." [12]

This reminiscence is selective, focusing on issues related to the debate around abstraction and figuration, so I have not recorded the profound impact of my first viewing of the work of Robert Colescott with Henry Geldzahler (my boss at the time) at the now-defunct Razor Gallery on West Broadway in the mid-1970s. I have also not recorded my infatuation with the collages of Betye Saar, which I first saw "in the flesh" at the tiny basement gallery that Monique Knowlton had at Prince Street and West Broadway. Betye's work revealed to me the underlying formalism of even the most accumulative impulse. Figural, abstract, pristine, overloaded, non-polemical and politically charged—in order to comprehend better the import of the 1970s, we must consider all its manifestations. By the end of the 1970s the explorations of black and Latino artists in particular, along with women, would comprise important aspects of the post-modern landscape as it unfolded in the 1980s.

Fred Eversley
Untitled, 1970
Polyester resin
20½ x 7¾ x 7½ inches
Collection of the Whitney
Museum of American Art,
New York, Purchase, 70.55

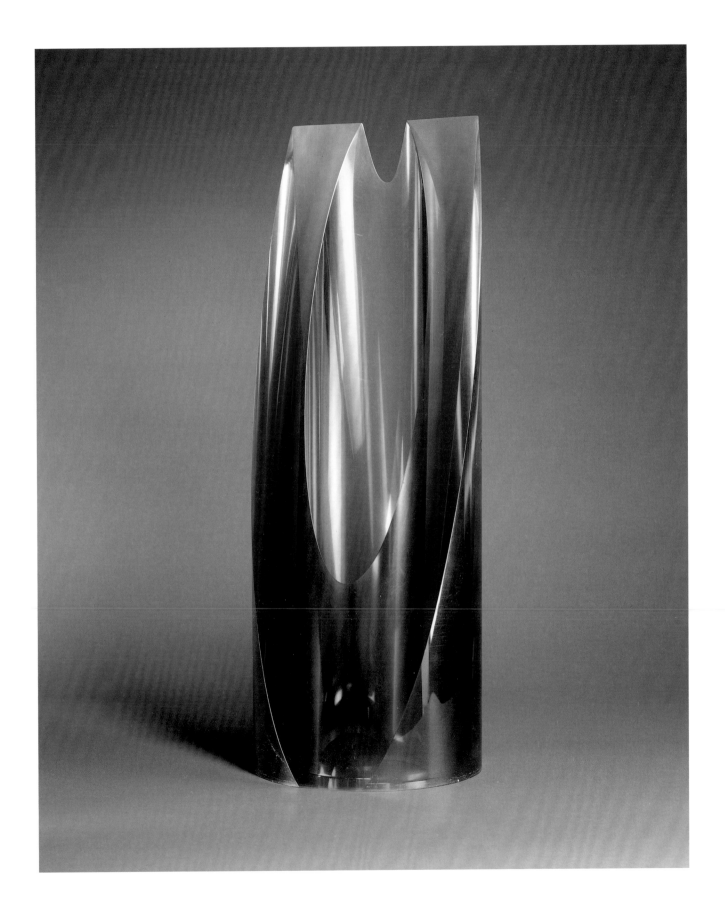

Fred Eversley
Untitled, 1972
Cast polyester resin
36 1/4 x 10 5/8 inches
Collection of the Solomon R.
Guggenheim Museum, New York,
Gift, Spring Mills, Inc., 1978
78.2439

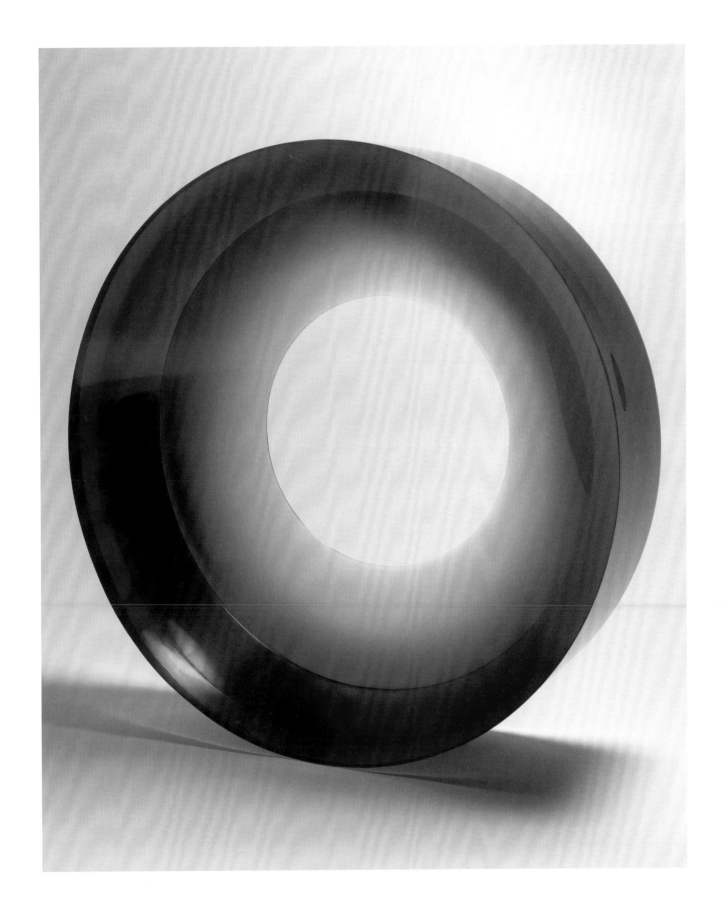

Sam Gilliam
Mars I, 1974
Acrylic on rice paper
20 x 24 3/4 inches
Collection of The Studio
Museum in Harlem,
Gift of Charles Cowles,
New York, 81.2.1

Sam Gilliam
Untitled, 1965–69
Mixed media with watercolor on paper
22 x 18 inches
Collection of The Studio Museum
in Harlem, Gift of Leslie Jane Wilder,
Alexandria, VA, 99.4.1

Sam Gilliam
Toward a Red, 1975
Acrylic and collage on
three strips of canvas
33 ¾ x 49 ¾ inches
Collection of The
Newark Museum, Gift of
Mimi Upmeyer, 1999

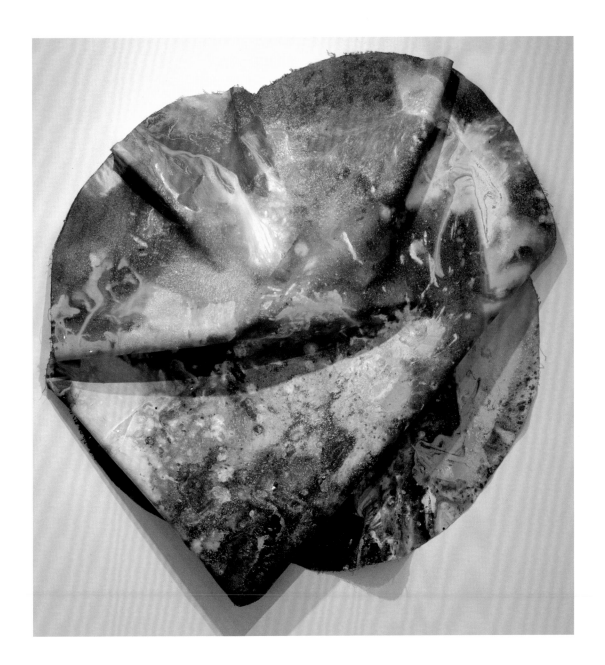

Sam Gilliam
Gram, 1973
Acrylic on canvas
57 x 60 inches
Collection of the Detroit Institute
of Arts, Gift of Patricia A. Fedor and
Christopher T. Sortwell, 1986.66
Photograph © 2006 The Detroit
Institute of Arts

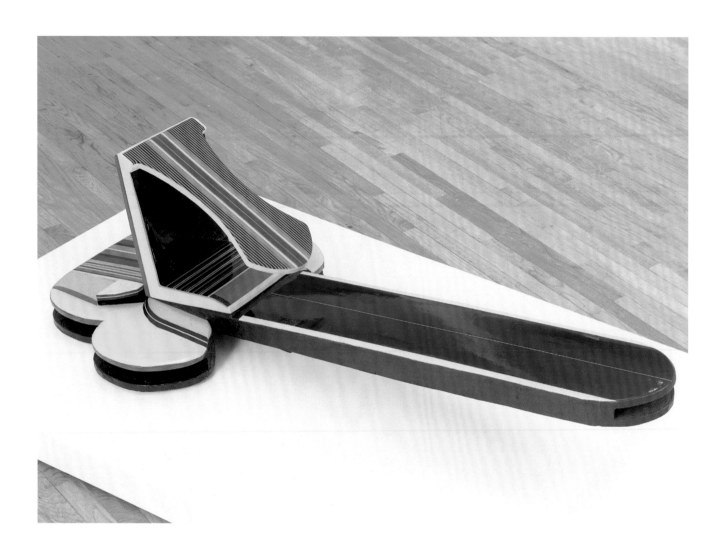

Daniel LaRue Johnson
Homage to Rene d'Harnoncourt, 1968
Painted wood
58 ½ x 30 ⅝ x 20 inches
Collection of Joy and I.J.
Seligsohn, New York
Photo: Marc Bernier

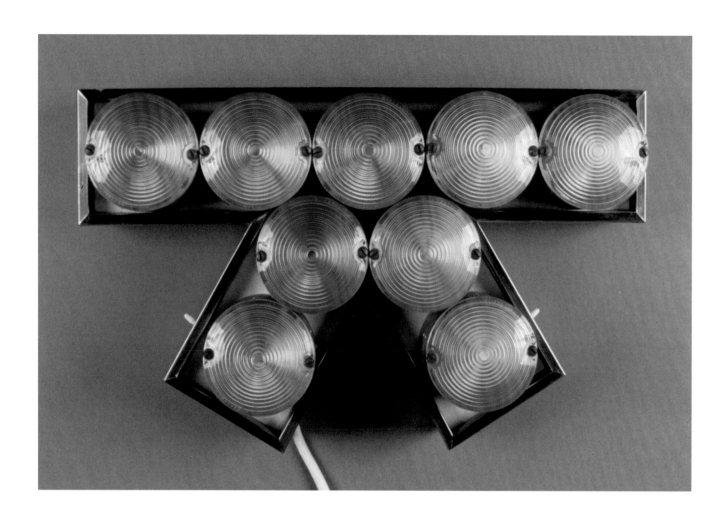

Tom Lloyd
Narokan, 1965
Electronic sculpture, aluminum, light
bulbs, plastic laminate
11 1/2 x 18 1/2 x 5 inches
Collection of The Studio Museum in
Harlem, Gift of Mr. and Mrs. Darwin K.
Davidson, 88.3

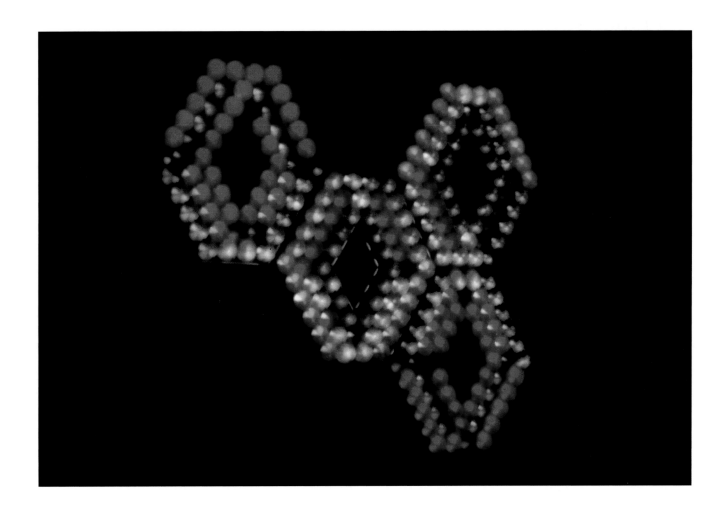

Tom Lloyd
Moussakoo (from the *Electronic
Refraction Series*), 1968
Electronic sculpture, aluminum,
light bulbs, plastic laminate
54 x 64 x 15 inches
Collection of The Studio Museum
in Harlem, Gift of The Lloyd Family
and Jamilah Wilson, 96.11

Free Jazz and the Price of Black Musical Abstraction

Guthrie P. Ramsey Jr.

Free Jazz and the Price of Black Musical Abstraction

Guthrie P. Ramsey Jr.

"If you don't experiment, you'll die."
Jack Whitten, 2005 [1]

Free jazz, the development in American music that shook jazz's traditional relationship to popular song form, controlled improvisation, blues tonality and rhythmic regularity, rose simultaneously with other social upheavals during the 1960s. Even bebop, a musical turn in jazz that transformed the genre into an "art," or America's classical music, seemed like a tame venture in comparison to the New Thing, as free jazz was called. The lightning-fast melodic, rhythmic and harmonic inventions of Charlie Parker, Dizzy Gillespie, Bud Powell and others became key signs of an Afro-Modernism at mid-century linked to numerous social, economic and political developments. Among these changes was a massive migration of southern blacks north and westward, a demographic shift that created an atmosphere for advances in education, economics and culture. Although these shifts formed the foundation for the Civil Rights victories of the 1950s and early 1960s, the free jazz movement remains linked to Black Power, a similar revolutionary push for African-American freedom.

The influence of the Black Power movement was considerable. It represented "the dominant ideological framework through which many young, poor, and middle-class blacks made sense of their lives and articulated a political vision for their futures." [2] The Black Power era—roughly from the mid-1960s to the mid-1970s—symbolized for many a new social order, a new radicalism. This social movement was not, however, a unified, static affair. Numerous political currents and agendas formed this new expression of "blackness": violence was advocated by some, peaceful resistance by others; a wide variety of new organizations appeared, each influenced by a wide range of philosophies; leftist leaning ideologues clashed with black middle class sensibilities; black feminism critiqued the overwhelmingly male centricity of the movement; and international concerns about

1 Jack Whitten. Personal conversation with author, 2005.
2 Eddie S. Glaude, Jr., "Black Power Revisited," *Is It Nation Time?: Contemporary Essays On Black Power and Black Nationalism* (Chicago: University of Chicago Press, 2002) 1.

3 For varied treatments of this music and its history, see: David G. Such, *Avant Garde Jazz Musicians Performing 'Out There'* (Iowa City: University of Iowa Press, 1993); Ekkehard Jost, *Free Jazz* (New York: Da Capo Press, [1974] 1994); David Litweiler, *The Freedom Principle: Jazz After 1958* (New York: Da Capo Press, [1984] 1990); Salim Washington, "'All the Things You Could Be by Now': Charles Mingus Presents Charles Mingus and the Limits of Avant-Garde Jazz," *Uptown Conversations: The New Jazz Studies*, eds. Robert G. O'Meally, Brent Hayes Edwards and Farah Jasmine Griffin (New York: Columbia University Press, 2004) 27-49; LeRoi Jones, *Black Music* (New York: William Morrow and Company, 1967); Robin D.G. Kelley, "Dig They Freedom: Meditations of History and the Black Avant-Garde," *Lenox Avenue: A Journal of Interartistic Activity* Vol. 3 (1997): 13-27; Frank Kovsky, *Black Nationalism and the Revolution in Music* (New York: Pathfinder, 1970); George Lewis, "Experimental Music in Black and White: The AACM in New York, 1970–1985," *Uptown Conversation: The New Jazz Studies*, eds. Robert O'Meally, Brent Hayes Edwards and Farah Jasmine Griffin (New York: Columbia University, 2004) 50-101; and Ronald M. Radano, *New Musical Figurations: Anthony Braxton's Cultural Critique* (Chicago: University of Chicago Press, 1993).

black and Latin folk around the globe resisted a solely African-American focus of the freedom struggle. What emerged was a highly politicized and quite diverse blackness that reclaimed, and in some instances reformed, black history, transformed its present and informed Afro-America's future. And it all took place under the slogan "Black Power."

During the 1960s, the northern and western cities to which previous generations of southern black migrants had fled during the 1940s began to collapse around them. As the capital base of these urban spaces rapidly progressed toward a stifling post-industrialism that would mark the 1970s, they imploded in riots, joblessness and structural decay. It became clear that the land of promise had not, in fact, kept its word. African Americans responded to black hopelessness with Black Power—an expression that, as we have learned, meant many things to many people.

Out of this multifarious, conflicted blackness exploded an array of cultural expressions in poetry, visual arts, theater, and music and its criticism. Dubbed the Black Arts Movement, its concerns formed a complex of radical spiritual, ideological and political priorities. One never gets the sense that it was ever a "culture for culture's sake" project. It had a razor's edge, and it cut to the bone. Although the masses of working-class African Americans sought pleasure in the activities of the mainstream culture industry, such as rock and R&B, musical works that white Americans adored as well, many writers, musicians and artists believed that free jazz formed the perfect soundtrack for Black Power. In their minds, a social revolution required a musical one as well.

And a musical revolution it was. What began as heady experiments among a smattering of musicians in more prosperous and socially stable times slowly gathered force and became a creative storm. But like Black Power, free jazz represented a particularly wide range of musicians and stylistic developments.

Jazz historians often trace the origins of free jazz to a long line of subtle innovations that date back as early as Duke Ellington's experiments with colorful timbres and long-form composition in the 1930s. During the 1940s and 1950s, in the long shadow of the bebop era, Lennie Tristano, Thelonious Monk, Miles Davis and Charles Mingus all stood out among their peers for their unorthodox approaches to jazz composition and improvisation. Many trace the foundations of free jazz to divergent musical precursors that displayed what might be called an experimental impulse.

Beginning in the late 1950s, the jazz idiom took its most dramatic departure from its time-honored conventions. Ornette Coleman, John Coltrane, Cecil Taylor, Albert Ayler, the Association for the Advancement of Creative Musicians (AACM) and Eric Dolphy all emerged as leaders of the New Thing, indeed, a thing so brutally new that in the ears of many it threatened the "natural" organic development of the genre. In other words, people wondered if free jazz was jazz at all, or even music for that matter. If bebop exaggerated melodic contour, harmonic extension and rhythmic disjuncture to the brink of abstraction, certainly free jazz broke through the genre's common-practice sound barrier, wreaking musical havoc, building controversial careers, mystifying old-school critics and attracting reverent converts.[3]

On the formal level, free jazz comprised a number of sweeping experiments in sound organization that broke with the past. Because the music was more collectively improvised than either swing or bebop, the division of labor between soloist and accompaniment was often obscured. Each competed for the listeners' attention because the music did not include a single emotional focal point, as is the case with, say, a pop singer backed by an orchestra or even a bebop soloist center stage in the soundscape of a virtuoso jazz trio. The New Thing's introduction of unconventional timbral approaches pushed the envelope of what was expected in African-American music in general and jazz specifically. Popular song-form harmonic patterns were shunned in favor of open structures that denied listeners familiar landmarks and placed new demands on musicians. Two

other significant breaks with past styles could be felt in tonality and rhythm. Exploitation of the tonal system marked bebop as singular; the flatted fifth together with abundant ninth, eleventh and thirteenth scale degrees made it a harmonically rich modernism. Free jazz took this tendency and pushed it further out, almost completely liberating the genre from the restrictions of functional harmony. Finally, out jazz tended to move through time unevenly, undermining the sense of swing that perhaps represented jazz's most distinctive feature.

Did free jazz—this radical experiment in sound—merely reflect the politically charged moment, or did it fuel it? Both. Evidence suggests, however, that because both sides of the equation, the musical and the social, were eclectic and diverse, drawing one-to-one homologies between the art and the times can be imprecise at best. Yet we can say this much: the political commitments of musicians such as Archie Shepp and writers such as Amiri Baraka (aka LeRoi Jones) made the connections unavoidable. At the same time, we must always think about agency. Artists, no matter how political, are rarely motivated by a singular idea. Rather, they are usually responding to a variety of factors. The forces of the culture industry and the search for an individual, immediately recognizable voice within a set field of musical parameters (i.e., the formal qualities of free jazz) have, for example, always provided inspiration for creativity.

Qualifications aside, the free jazz movement represents the most insistent consummation of social, cultural and identity politics in jazz's history. There was undeniable cross-fertilization of performance rhetoric. During the 1960s, Amiri Baraka's recitation style was heavily influenced by Albert Ayler's cultivated saxophone yelps. Charlie Mingus and Sun Ra both experimented with poetry, and Archie Shepp was both a playwright and poet. Music was a central preoccupation, as the poets were often accompanied by jazz and R&B. The mutual influence among black artists of all stripes could also be seen in their similar attempts to control the modes of production of their work.

4 Lorenzo Thomas, "Ascension: Music and the Black Arts Movement," *Jazz Among the Discourses*, ed. Krin Gabbard (Durham and London: Duke University Press, 1995) 256-275.

5 Robert Farris Thompson, *Flash of the Spirit: African and Afro-American Art and Philosophy* (New York: Vintage Books, 1983) xiii-xiv.

6 Albert J. Raboteau, *Slave Religion: The "Invisible Institution" in the Antebellum South* (New York: Oxford University Press, 1978) 4.

7 Thomas 262.

8 See, for example: Houston A. Baker Jr., *Blues, Ideology, and Afro-American Literature: A Vernacular Theory* (Chicago: University of Chicago, 1984); Houston A. Baker Jr., "Critical Change and Blues Continuity: An Essay on the Criticism of Larry Neal," *Afro-American Poetics: Revisions of Harlem and the Black Aesthetic* (Madison: University of Wisconsin Press, 1981) 140-59; Craig Hansen Warner, *Playing the Changes: From Afro-Modernism to the Jazz Impulse* (Urbana: University of Illinois, 1994); Richard J. Powell, ed., *The Blues Aesthetic: Black Culture and Modernism* (Washington D.C.: Washington Project for the Arts, 1989); Amiri Baraka, "'The Blues Aesthetic and the Black Aesthetic': Aesthetics as the Continuing Political History of a Culture," *Black Music Research Journal* 11 (Fall 1991): 101-109; J. Martin Favor, "'Ain't Nothin' Like the Real Thing Baby': Trey Ellis's Search for New Black Voices," *Callaloo* 16 (Summer 1993): 694-705; Greg Tate, "Cult Nats Meet Freaky-Deke: The Return of the Black Aesthetic," *Village Voice Literary Supplement* (December 1986): 7, reprinted in *Flyboy in the Buttermilk*; George Lipsitz, "Listening to Learn and Learning to Listen: Popular Culture, Cultural Theory, and American Studies," *American Quarterly* 42 (December 1990): 615-36; Portia Maultsby, "Africanisms in African-American Music," *Africanisms in American Culture*, ed. Joseph E. Holloway (Bloomington: Indiana University, 1990); and Portia Maultsby, "Africanisms Retained in the Spiritual Tradition," *International Musicological Society, Berkeley 1977*, ed. Daniel Heartz and Bonnie Wade (Basel: Bärenreiter, 1981) 75-82.

Coltrane, for example, spearheaded efforts to start a record label and booking agency, and Baraka founded the Black Arts Repertory Theater/School, sponsored concerts for prominent free jazz artists and claimed that the cultural politics of identity should be central to jazz criticism. Such efforts demonstrated how these artists formed an unprecedented community of social and cultural activism.[4]

Free jazz's musical conventions can claim two streams of influence. There existed during the 1960s a huge investment in the claim that by rejecting many of the melodic, harmonic, rhythmic and even timbral tenets of common-practice Western art music, the New Thing was returning black music to its African roots. The spirit behind this idea was a well-traveled one. In fact, scholars and cultural critics of the African-American experience have long sought to find continuities among the lives of black people throughout the African Diaspora, especially as they manifest in cultural expressions such as music, literature, cuisine, religion, visual arts and dance.

The forced migration of Africans throughout the Atlantic world spawned myriad cultural forms, which, though displaced and transformed, share a core set of distinctive and unifying attributes that link them to the (black) Old World. Art historian Robert Farris Thompson called it a "flash of the spirit." The term describes for him "*visual* and *philosophic* streams of creativity and imagination, running parallel to the massive musical and choreographic modalities that connect black persons of the western hemisphere, as well as the millions of European and Asian people attracted to and performing their styles, to Mother Africa ... The rise, development, and achievement of Yoruba, Kongo, Fon, Mande, and Ejagham art and philosophy fused with new elements overseas, shaping and defining the black Atlantic visual tradition."[5] Religious scholar Albert Raboteau sees this continuity in religion as well, despite efforts to remove the cultural memory of slaves: "In the New World slave control was based on the eradication of all forms of African culture because of their power to unify the slaves and thus enable them to resist or rebel. Nevertheless, African beliefs and customs persisted and were transmitted by slaves to their descendants. Shaped and modified by a new environment, elements of African folklore, music, language, and religion were transplanted in the New World."[6] These notions were adopted by free jazz artists to tie their musical works to both historic Africa and the struggles of black people around the globe. As early as 1964, Marion Brown insisted, for example, that because many black musical forms were passed down from generation to generation orally, he could discern African tribal musics in the riffs and runs of contemporary black music such as jazz and R&B, an idea that many others began to champion.[7]

The push to locate continuity with the African past was central to Black Power rhetoric, and for its architects, black music underscored this coherence poignantly. This strain of thinking has been so influential in Black Nationalist rhetoric that blues and jazz have continued to provide engaging metaphors, models and themes for a host of studies aimed at elucidating black cultural production and even larger issues in American culture, especially literature.[8]

Indeed, exploration of the dynamic relationship between black Old and New World practices traditionally has been regarded as a valuable way to explain the power and especially the *difference* in black music-making. Historically, this subject has attracted considerable attention: from the antebellum writings of American journalists, missionaries, foreign travelers and schoolteachers, to the 20th-century work of critics and scholars.[9] Conflicting notions about African-American music's African-ness (blackness) or its hybridity (Afro/Euro-ness) fuel this continuing debate. The Black Arts Movement championed the idea that black musical creativity was the result of its engagement of African ways of "musiking," ways that revealed themselves in a range of techniques, styles and repertoires. The musical styles born of this seemingly endless capacity to codify

the stuff of Others into something with a black difference, to cross-pollinate real and imagined boundaries, have proceeded throughout the years without reflecting the conflict expressed in the discourse *about* these musical texts.

At the same time, however, one cannot dismiss as irrelevant the strain of experimentation in Western art music that also discarded the tonal system and other familiar qualities of "classical music." Musicologist Susan McClary has brilliantly identified the economy of prestige within which avant-garde composers such as Roger Sessions, Arnold Schoenberg, Milton Babbitt and Pierre Boulez worked. Difficulty, audience alienation, disdain of the popular and dismissal of signification grounded in social meaning—the meaning that makes music compelling to most listeners—were worn like badges of honor and consigned their work to a condition she calls "terminal prestige." While classical musics have long functioned as repositories for aristocratic and then middle-class sensibilities, desires, struggles and fulfillment, they have become invested (particularly the classical avant-garde) in denying the idea that the most prestigious forms of instrumental music signify social meaning.[10]

The formal qualities of this "Western" avant-garde and the jazz avant-garde discussed here may strike many casual listeners as possessing a number of similarities. But a comparison of the claims that each group made about itself is instructive. As literary scholar Henry Louis Gates once argued: "Anyone who analyzes black literature must do so as a comparativist, by definition, because our canonical texts have complex double formal antecedents, the Western and the black."[11] The same is obviously true of black music.

If the Western avant-garde (so-called for my purposes here) subscribed to what McClary called the "difficulty-for-the-sake-of-difficulty"[12] attitude, free jazz was assigned more politically charged meanings. Don't get me wrong. Jazz has over the last 50 or so years actively sought upward mobility on the cultural hierarchies ladder, and has done so with chal-

9 For comprehensive bibliographic treatment of this material, see: Eileen Southern and Josephine Wright, eds., *African-American Traditions in Song, Sermon, Tale, and Dance, 1600s-1920: An Annotated Bibliography of Literature, Collections, and Artworks* (New York: Greenwood Press, 1990). Also see: Dena Epstein, "Slave Music in the United States Before 1860 (Part I)," *Notes* 20 second series (Spring 1963): 195-212; Dena Epstein, "A White Origin for the Black Spiritual? An Invalid Theory and How it Grew," *American Music* 1 (Summer 1983): 53-9; Dena Epstein, "African Music in British and French America," *Musical Quarterly* 59 (January 1973): 61-91; Dena Epstein, "Documenting the History of Black Folk Music in the United States: A Librarian's Odyssey," *Fontis Artis Musicae* 23 (1976): 151-7; Dena Epstein, *Sinful Tunes and Spirituals: Black Folk Music to the Civil War* (Urbana: University of Illinois, 1977).

10 Susan McClary, "Terminal Prestige: The Case of Avant-Garde Composition," *Cultural Critique* 12 (Spring 1989): 57-81.
11 Henry Louis Gates Jr., *The Signifying Monkey: A Theory of African-American Literary Criticism* (New York: Oxford University Press, 1988) xxiv.
12 McClary 64.
13 David Ake, *Jazz Cultures* (Berkeley: University of California Press, 2002) 62-82.

lenging music. Critics and musicians have fought for the legitimacy of the genre, working to change its status to a bona fide art, replete with anxieties about popular culture. But as we learned above, the difficulty of free jazz was invested with a social function. Furthermore, because the composers of the Western avant-garde were subsidized by prestigious university and college music departments, they could afford to shun commercialism outside of their protected circle. Jazz musicians, on the other hand, have always had to cultivate careers within the culture industry, competing for their share of the pie to survive. Indeed, the economy of prestige was quite different for free jazz musicians.

Both, however, were masculinist discourses. Male musicians formed the core of each, with seemingly little room for the creative work of women. If female musicians had made inroads into the ranks of early jazz, swing and bebop, free jazz was categorically a boys club. As I noted above, the black feminist agenda that emerged in the 1960s and 1970s was not considered central to the thrust of Black Power, and according to some, this undermined the scope and potential of the project. Thus, the free jazz movement reflected this lacuna. Yet at the same time, musicologist David Ake has recently drawn attention to, and complicated, the view of free jazz as simply masculinist. Ornette Coleman, he argues, provided a new paradigm for black male jazz musicians by expanding what were acceptable representations of masculinity in jazz. Coleman achieved this in his non-teleological compositions, his preppy, non-slick demeanor in cover art photographs, his vegetarianism and his non-womanizing reputation, which all challenged the conventional codes of jazz masculinity in the late 1960s.[13]

Cornel West has recently argued that the Black Power era revealed a crack in what was once considered a monolithic equal rights struggle. As an emergent black middle class grew apart from the black working class and the working poor, the resulting stratification within Afro-America threatened traditional alliances. This stratification, of course, could be seen in the jazz world, as musicians with diverse educational and social backgrounds began to constitute the community to a greater degree than they had before. Musical diversity followed. No longer could one assume that, say, jazz and R&B or even gospel were the musics of the black working class exclusively. As free jazz showed us especially, the rich diversity of experiences spawned experimentation. And as Jack Whitten reminds us in the epigraph above, there is much at stake both artistically and socially if one ceases to experiment.

But free jazz musicians paid a price for their experiments. Although their connections to the freedom struggle were clear, there is little indication that the black masses fully embraced the form as their own, as their flag, so to speak. By challenging the arbiters of taste in both Western music and the bebop old guard, free jazz musicians pushed the envelope and themselves out of the cherished circle of common-practice jazz. But the price of not freeing jazz would have been more costly, indeed. Jazz could have died.

The Re-selection of Ancestors: Genealogy and American Abstraction's Second Generation

Courtney J. Martin

The Re-selection of Ancestors: Genealogy and American Abstraction's Second Generation

Courtney J. Martin

In a society as a whole, and in all its particular activities, the cultural tradition can be seen as a continual selection and re-selection of ancestors. Particular lines will be drawn, often for as long as a century, and then suddenly with some new stage in growth, these will be cancelled or weakened, and new lines drawn.[1]

Abstract Expressionism, the dominant style of art in America during the post-war years of the 1940s and the early 1950s, is re-constructed as if it were the singular platform for all American art to follow. The growth of the American art market as an entity, independent of Europe, is interrelated with America's mid-twentieth century prosperity and its burgeoning position as a world power. Staged in the militaristic terms of "triumph" and "stolen ideas," the first generation of abstract art is constructed as the victorious and direct link to the later styles of Minimalism, conceptual art, pop art, installation art and performance art.[2] But cultural tradition, as Raymond Williams points out, is predicated on the ability of the contemporary moment to chart its cultural awareness based on the selection of lived and periodized cultures.[3] The movement from first-generation abstract art to the expanded fields of art was not a continuous, chronological progression, but was intersected by a second generation of abstract painting and sculpture in the 1960s.[4] This second genera-

tion selected stylistic aspects from the first, which were then used to expand painting into new forms of art. By reducing the elements of a composition, working with new technology and materials, and expanding the options for pictorial support, the second generation of abstract artists shuttled painting from the flat ground, which it had occupied since antiquity, into the spatial forms that would be re-classified as variable objects and as "three-dimensional work."[5] Abstract painting's newly acquired mobility greatly affected abstract sculpture as well. Abstract sculptors increased in number from the first to the second generations, as did their facility with non-traditional materials, sound and moveable components. The conversations between and within the two groups eased the artificial division between media that had plagued the first generation. In the process, the second generation delineated itself from the first and shaped the new forms of art that were coexistent with it.

The Ancestors

In America, the first generation of abstraction was marked as much by its painting style as it was by its institutions. Designated as the new capital of art after World War II, New York was home to most of the abstract artists in the country, with many resident in lower Manhattan. They caroused with their literary

1 Raymond Williams, *The Long Revolution* (New York: Columbia University Press; London: Chatto & WIndus, 1961) 52-53.
2 Serge Guilbaut, *How New York Stole the Idea of Modern Art: Abstract Expressionism, Freedom, and the Cold War* (Chicago: Chicago University Press, 1983); Irving Sandler, *The Triumph of American Painting: A History of Abstract Expressionism* (New York: Praeger, 1970).
3 Williams 52-53.
4 The term "second generation" has been used derisively to denote those artists not acknowledged in the primary canon of abstraction. I use the term "chronologically" to refer to artists who began working after the advent of American abstraction in the 1940s and 1950s.
5 Donald Judd, "Specific Objects," *Arts Yearbook* 8 (1965): 74-82. In this essay, Judd explicates the departure from the traditional forms of painting and sculpture into a third term, called three-dimensional work.

Dan Flavin
a primary picture, 1964
Red, yellow and blue
fluorescent light
2 x 4 feet
Photo: Billy Jim, New York
© 2006 Stephen Flavin/Artists
Rights Society (ARS), New York

6 Harold Rosenberg, "The American Action Painters," *The Tradition of the New* (New York: Horizon, 1959) 25, 26-28.
7 Robert Goldwater, "Reflections on the New York School," *Quadrum* no. 8 (1968): 20, 26, 27, 30, 31.
8 Greenberg also called Abstract Expressionism "American-Type Painting," but chose the former title after claiming that American artists were a part of the lineage of European art that began in the Renaissance and emanated from antiquity.
9 Clement Greenberg, "Post Painterly Abstraction," in *Post Painterly Abstraction*, an exhibition organized by the Los Angeles County Museum of Art and sponsored by the Contemporary Art Council (Los Angeles: F. Hensen Co; 1964) 5-8.
10 Greenberg 5-8.

and musical contemporaries at their primary haunt in the Village, the Cedar Tavern. The circle of artists was galvanized by the successes of Willem de Kooning and the critics' favorite, Jackson Pollock. Divided within their ranks by what they should be called and how their work should be perceived, the artists debated formally for nearly two years at "Studio 35" meetings and informally for several more through the "Club." And, under the aegis of its founding director, Alfred H. Barr Jr., the Museum of Modern Art (MoMA) literally installed abstraction as the preeminent expression of Modernism.

The clubby, male atmosphere of American abstraction was backed by a powerful machine comprised of curators, critics and dealers. Ironically, the leading galleries were owned by women, Betty Parsons and Peggy Guggenheim, who along with Charles Egan and Leo Castelli, marketed abstract art internationally. In the leading art magazines, *Art News*, *Arts Magazine* and *The Magazine of Art*, critics tussled over ideological control of the style. Harold Rosenberg called abstract artists "American Action Painters," a name he coined to describe the action associated with Jackson Pollock's painting style and the significance of performative gesture in abstract painting.[6] The Marxist intellectual Meyer Schapiro, the painter and academic Hale Woodruff, the Londoner Lawrence Alloway and Robert Goldwater, who preferred the geographic term "New York School," were Rosenberg's print adversaries.[7] In time, Rosenberg and Schapiro's terms were bested by Clement Greenberg's evocation, "Abstract Expressionism." Abstract Expressionism conveyed the similarities of the varied non-representational painters, while linking abstraction to European histories of Expressionism.[8]

"Post Painterly Abstraction," aka the "New Art"

In 1964, after nearly twenty years of support, Greenberg halted production on the machine of the first generation.

Abstract Expressionism was, and is, a certain style of art, and like other styles of art, having had its ups, it had its downs. Having produced art of major importance, it turned into a school, then into a manner, and finally into a set of mannerisms. Its leaders attracted imitators, many of them, and then some of these leaders took to imitating themselves. Painterly Abstraction became a fashion, and now it has fallen out of fashion... [9]

In place of painterly abstraction, Greenberg offered a successor, "post painterly abstraction."[10] According to Greenberg, the first generation of abstract artists were the continuation of the canon of painting that replicated nature and repeated known styles, adapting and reinterpreting while invigorating the practice. "Painterly abstraction" was a derivative of the Swiss art historian Heinrich Wölfflin's binary designations, "painterly" and "linear." If "linear" was crisp and definite, "painterly" was loose and blurry. The new artists were more equipped to delve into the parameters of abstraction, specifically linearity. Their explorations would be evident in contrasting colors and the incorporation of geometric lines and grids into their work. The early "painterly" and the later "post painterly" artists were a chronological succession in Greenberg's totalizing ideology of Abstract Expressionism. His declarations came in the form of an essay for an exhibition, also entitled *Post Painterly Abstraction*, which debuted at the Los Angeles County Museum of Art in April 1964. The exhibition traveled to Minneapolis and Toronto, skipping New York in favor of the cities recently excavated by curators and art dealers as new sites of Modernist patronage due to their affluence and progressive political values.

Post Painterly Abstraction showcased the work of thirty-one artists, many of whom broke with the first generation by living outside of New York. In the 1960s, Washington, D.C., reemerged as a focal point for the nation, due in part to the vitality and youth of John F.

Kennedy's administration. As the events of the decade unfolded, D.C. became the barometer of national unrest; the first sign was the demonstration for civil rights in 1963, which was followed by successive protests over the Vietnam War. Artists Gene Davis, Morris Louis, Howard Mehring, Kenneth Noland, Alma Thomas and, later, Sam Gilliam worked and lived in D.C. during this turbulent era. In addition to the D.C. artists, there was a contingent associated with Bennington College in Vermont comprised of Paul Feeley, Helen Frankenthaler and Jules Olitski.[11] Of Greenberg's choices, only Frankenthaler, Al Held and Ellsworth Kelly resided in New York. Of this group, Frankenthaler was the only one to interact significantly with the old guard.[12]

Greenberg's announcement of a new set of abstract painters seemed both abrupt and unfounded. Many of the "painterly" abstract artists were in the middle of their careers, rather than at the end, as he suggested. Greenberg's views on artists had always been polarizing and his allegiances had been known to shift. Despite his formalist claims that the new painting had surpassed the old, many felt that his assessment was a ruse to ensure that he alone guided a new generation of artists into prominence. There was, however, evidence that abstraction was evolving, and he had not been the first to take notice. Perhaps his impetus was generated by the exhibitions that preceded his, which hinted at new approaches to non-representational painting. The first of these was *Sixteen Americans*, curated by Dorothy Miller at MoMA in 1959. As the first full-time curator at MoMA, Miller organized the show as a continuation of a series of group exhibitions of American art. However, it differed from the earlier exhibitions in that it brought together young artists from across the nation.[13] Her catalogue essay suggests that she was keen to de-center abstraction from New York, thereby distancing it from the first generation.

Sixteen Americans grouped Ellsworth Kelly's flat paintings with Jasper Johns' sculptural paintings. Louise Nevelson's wooden walls of abstract shapes were shown with Robert Rauschenberg's experimental combinations of fabric, paint and debris, which he called combines. Following *Sixteen Americans*, the Guggenheim Museum mounted *American Abstract Expressionists and Imagists* in 1961, which included Frankenthaler, Held, Kelly, Louis, Noland and Frank Stella. *Geometric Abstraction in America* opened in 1962 at the Whitney and featured Held, Kelly, Noland, Stella and others who mingled non-representational forms with known lines and shapes. In the following year, Held, Kelly, Louis, Noland and Stella were in the Jewish Museum's survey of abstract art, *Toward a New Abstraction*. Each of these exhibitions signified that abstract art had been absorbed, but not exhausted, by the public.[14] In turn, they proposed a new direction in abstraction similar to Greenberg's "post painterly" model. Color and geometry were significant, as was painting that was not strictly two-dimensional.

Perhaps the last show to offer second-generation abstract artists as a newly minted attraction was 1965's *Three American Painters* at the Fogg Art Museum.[15] Curated by Harvard graduate student Michael Fried, *Three American Painters* showcased Olitski, Noland and Stella as exemplars of the "new art." This exhibition marked Fried's early relationship to "Greenbergian" formalism. As such, he privileged painting as the primary expression of modern art. And, like in Greenberg's choices, color was a chief concern. Of course, he linked Olitski, Noland and Stella with the earlier abstract artists and with classical painting under Greenberg's Wölfflin-inflected formula. But Fried was interested in the "new art's" ability to render illusion on a flat canvas and explore pictorial structure. Though he feared the "expansion of the possibilities of the pictorial," and would later denigrate the shift from art-making to object-making as theatrical, he regarded the expansion of the pictorial in painting as a Modernist achievement. [16]

11 Kenneth Noland was split between institutions and affiliations in D.C. and Vermont.
12 According to the revised catalogue, Greenberg chose the majority of artists in the show, save for the artists from the West Coast.
13 Dorothy C. Miller, *Sixteen Americans* (New York: Doubleday, 1959).
14 While not strictly abstract art exhibitions, the 1964 Whitney Annual and the 1962 Seattle World's Fair exhibition, *Art Since 1950, U.S.A.*, were dominated by abstract artists. The Whitney showed a mix of emerging and established artists. Conversely, the World's Fair exhibition was intended to be a national display of American artists. Younger abstract artists were included as a show of force; they proved that America's hold on the art market had not waned after the first generation's success.
15 *Three American Painters*, Fogg Art Museum, Harvard University, April 21–May 30, 1965.
16 Michael Fried, *Three American Painters* (Boston: Fogg Art Museum, Harvard University, 1965) 47; Michael Fried, "Art and Objecthood," *Artforum* 10 (1967). Calling minimal art a literal form of art, Fried wrote, "the literalist espousal of objecthood amounts to nothing other than a plea for a new genre of theater; and theater is now the negation of art."

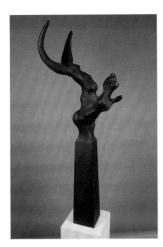

Richard Hunt
Hybrid Form #3, 1970
Cast bronze
56 x 24 x 20 inches
Collection of The Studio Museum
in Harlem, Gift of Mr. and Mrs.
Samuel Shore, 83.11

17 Lucy Lippard, "Diversity in Unity: Recent Geometricizing Styles in America," *Art Since Mid-Century* (Greenwich: New York Graphic Society, 1971) 231-256.
18 Carl Andre, "Preface to Stripe Painting," *Americans 1942-1963: Six Group Exhibitions*, ed. Dorothy C. Miller (Museum of Modern Art: New York, 1972) 76. Dominic Rahtz provides an important connection between Andre's minimal sculpture and Stella's stripes. According to Rahtz, Andre used the *Sixteen Americans* essay to play on the agitation between new abstraction and first-generation abstraction. Dominic Rahtz, "Literality and Absence of Self in the Work of Carl Andre," *Oxford Art Journal* 27, no. 1 (2004): 61-78. Earlier, Benjamin Buchloh commented on the relationship of painting and minimal painters and sculptors, namely Stella and Robert Morris. Benjamin H. D. Buchloh, "Conceptual Art 1962-1969: From the Aesthetic of Administration to the Critique of Institutions," *October* 55 (1990): 105-143.

Selection and Re-selection

The new abstraction engaged with color in a markedly different manner than the first generation had. The earlier artists either adhered to Greenberg's insistence on vibrant colors or reacted against him. Following Ad Reinhardt's black palette, younger artists experimented with monochromatic painting. The 23-year-old Stella painted a series of "black" paintings that were included in *Sixteen Americans*. Interspersed with geometrically precise white lines, Stella's paintings were not imitations of Reinhardt's, who as Lucy Lippard has suggested, introduced geometry via the line along with Barnett Newman.[17] These lines, called "stripes" by the Minimalist artist Carl Andre, replicated the width of the painting's frame, calling attention to the space the painting occupied on the wall and the varying degrees of symmetry within the composition.[18] Their colleague in the Studio 35 sessions, Norman Lewis, began to paint linear schemes on obviously rectilinear canvases by the late 1940s, and Stella's striped paintings transgressed the boundary between flat and raised without becoming a relief and ushered geometry in to the second generation. This illusion of depth soon gave way to canvases that were shaped and, later, to canvases that stood on their own. Alvin Loving also moved from hardedge painting to shaped canvases in the 1960s. His 1969 solo show at the Whitney Museum included numerous investigations of geometry and elevated pictorial planes. Loving and Stella's free-standing paintings were spatially dynamic, recalling the emotive energy of gestural painting fixed within a static space.

Like Stella, Robert Ryman began his new foray into abstraction by abandoning figurative work to paint in white. Turning from his monochromatic palette, Ryman experimented with material and construction. He painted on paper and metal and provocatively affixed his work to the wall with tape or pins. Both Stella and Ryman provided launching points for Minimalism's reduced aesthetic. Minimalism's inverse, assemblage, was a material exploration

as well. Rauschenberg and Romare Bearden exhausted the abstract compositional possibilities of built form in found items and print matter, respectively.

Second-generation artists who used color tended to do so in an investigative manner. Greenberg attempted to group Frankenthaler, Noland and Olitski with Mark Rothko by labeling them colorfield artists. Rothko juxtaposed close tones and intense hues on large areas of the canvas. The resulting fields of color were complementary. Unlike Rothko's, Olitski's paintings performed an oppositional act. He spray-painted disparate colors together, creating jarring compositional relationships. Ed Clark, Frankenthaler, Olitski and Noland's paintings were larger than the earlier abstract paintings; many even eclipsed Pollock's canvas monuments. Their ambitious scale rendered the color compositions adversarial and, at times, aggressive.

With the proliferation of synthetic paint varieties in the late 1950s, Frankenthaler switched from oil to acrylic and began to stain unprimed canvases without the use of a paintbrush. Staining was the method she adapted from Pollock's process of dripping and pouring paint directly onto the canvas. The removal of the paintbrush and the addition of the natural color of the canvas altered the tonal quality of her work so her paintings appeared flatter, an achievement that had a philosophical undertone in that the paintings' structure was revealed to the viewer. The emphasis that Frankenthaler and, in turn, Clark, Louis, Noland, Olitski and Stella placed on the removal of the brush from the canvas and the assertion of the ground of the canvas aided the development of art concerned with process. Color was but one of many mechanisms of the object to be manipulated and adjusted. The canvas was another. The hardedge painter William T. Williams led a group that transferred monumental geometric murals onto residential buildings in New York. This fusion of civic design and the ideologies of the ever-expanding field of art further ignited

issues of pictorial space, size in relation to color and sculptural dimensionality.[19]

The absence of the paintbrush further allied the new painting with conceptual and minimal sculpture, such as that of Donald Judd and Dan Flavin. Their mature work bore little or no trace of the physical contact between the object and its maker. Judd's idea of "three-dimensional work" was assembled through production methods akin to commercial manufacturing rather than fine art. The intense mechanisms of skilled labor, such as welding and metal handling, became the primary methods of abstract sculpture, as in Richard Hunt's steel work. This position was explicated in Sol LeWitt's manifesto on conceptual art, which was published in the newly formed text, *Artforum*.[20] *Artforum* (1962), *It Is: A Magazine for Abstract Art* (1958) and, later, the journal *October* (1975) became the spaces of transition between the new abstract painting and sculpture and the new forms of art.[21]

Ryman, Stella, Robert Mangold and Jo Baer were the painters most closely associated with Minimalism due to their interest in geometric grids, the spatial dimensionality of their work and their sometime collegiality with the minimal sculptors. Reacting to the feeling that Minimalism was edging out the painters in favor of the sculptors, Baer wrote a scathing letter to *Artforum* addressing the co-opting of Minimalism's ideas by the sculptors.[22] Baer's letter and even Minimalism as a movement were charged by the contentious nature of the country, which was polarized at that time by competing platforms, including race relations, the changing roles of women in the public and domestic spheres, and the ever-present Vietnam War.

The actions of the nation over the latter half of the twentieth century have been reflected in and reciprocated by abstract art. If the first generation's task was to free its methodology from Europe, the second generation of abstraction's cultural awareness was predicated upon the motility of the first. The Hegelian interchange between the two iterations of abstract art was marked by Greenberg's coda on the first generation. But we know that abstraction did not end there, just as we know that it did not begin there. Abstract Expressionism's complicated relationships with Cubism, primitive art and Dada, as well as with jazz, semiotics and post-structural theory, were precursory clues to the position that later abstract painting and sculpture would hold within the expanded fields of art- and object-making in the late twentieth century. The new forms of art bore traces of late abstract painting, just as late abstract painting and sculpture resembled earlier Abstract Expressionism. Yet each evolved into discrete entities.

Second-generation abstraction has a distinct look and a definitive style that is marked by its scale, innovative pictorial structures and material whimsy. Though different, abstract art from the 1960s to the 1980s balances remnants from the first generation of abstraction. It is a complex blend of exploratory zeal, aesthetic confidence and caution about critical polemics. These elements can be found in the art that followed it. To return to Williams' assertion of a culture's "continual selection and re-selection of ancestors" for advancement, progress in American abstract art could be tracked by noting the use of strategic remnants of the past while providing a method of innovation from which to depart. The second generation of artists innovated the composition of abstraction in ways that influenced another generation of artists who were not necessarily devoted to abstraction, but who were inspired by its cultural ideal.

Jo Baer
*Vertical Flanking Diptych
(green, large)*, 1966–74
each panel 96 x 68 3/4 inches,
96 x 145 3/4 overall
Collection of Howard and
Cindy Rachofsky, Dallas
Photo: Tom Powel

19 Guy Garcia, Melvin Edwards, Billy Rose and William T. Williams painted abstract murals in upper Manhattan under the moniker "Smokehouse Painters." Michel Oren situates the social and political implications of their urban murals in Michel Oren, "The Smokehouse Painters, 1968–70," *Black American Literature Forum* 24, no. 3 (1990): 509-531.
20 Sol LeWitt, "Paragraphs on Conceptual Art," *Artforum* vol. 5, no. 10 (Summer 1967): 77-83.
21 In 1975, Rosalind Krauss and Annette Michelson left their positions as contributing editors at *Artforum* to found *October*. *October*'s name signified its political bent and its interest in viewing contemporary art within the larger scheme of cultural practices.
22 Jo Baer, "Letters," *Artforum* vol. 6, no. 1 (1967): 5-6. According to an interview with Judith Stein, Baer first wrote personal letters to Michael Fried after reading his article "Art and Objecthood" in *Artforum* in which she felt he misread all of Minimalism by way of misreading Donald Judd, and to Robert Morris, who she felt was unfair to painting in his article "Notes on Sculpture" in *Artforum*. Judith E. Stein, "The Adventures of Jo Baer," *Art in America* 91, no. 5 (2003): 104-111, 157.

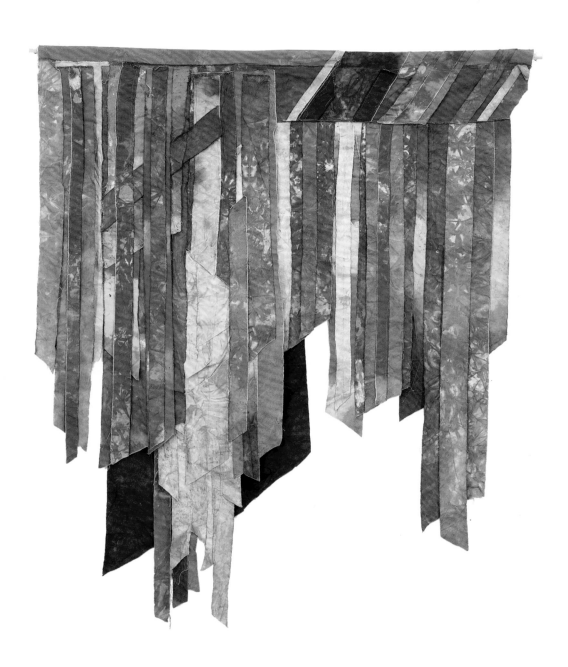

Al Loving
Untitled, c. 1975
Dyed canvas
68 x 60 inches
Collection of Alicia Loving-Cortes
and Anne Bethel, New York
Photo: Marc Bernier

Al Loving
Septehedron 34, 1970
Synthetic polymer on canvas
88 ¼ x 102 ¾ inches
Collection of the Whitney Museum
of American Art, New York; Gift of
William Zierler, Inc. in honor of
John I. H. Baur, 74.65

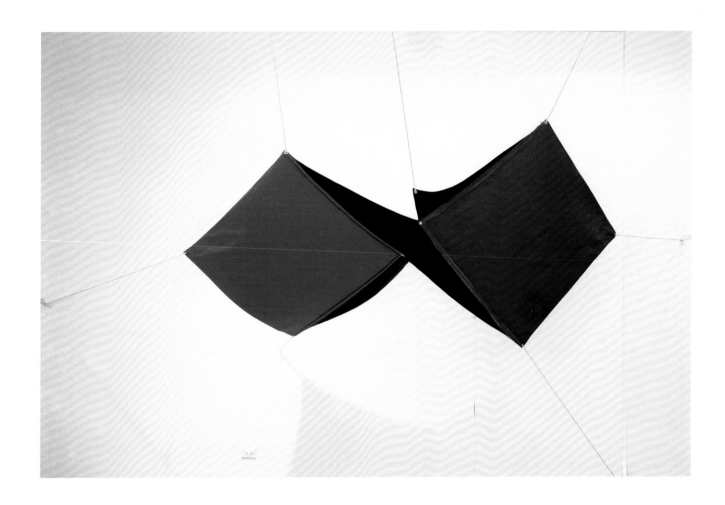

Joe Overstreet
Saint Expedite A, 1971
Acrylic on canvas
62 x 96 inches
Courtesy of the artist and
Kenkeleba Gallery, New York
Photo: Orcutt & Van der Putten

Howardena Pindell
Feast Day of Iemanja II, December 31, 1980
Acrylic, dye, paper, powder, thread,
glitter and sequins
86 x 103 inches
Collection of The Studio Museum
in Harlem, Gift of Diane and Steven
Jacobson, New York, 86.2

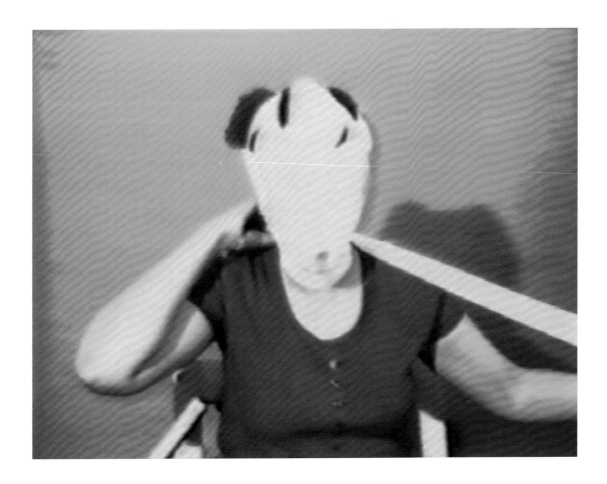

Howardena Pindell
Free, White and 21, 1980
VHS
TRT 12:15
Courtesy of The Kitchen,
New York

Howardena Pindell
Untitled #2, 1973
Ink and collage on paper
22 1/2 x 17 1/2 inches
Collection of The Metropolitan
Museum of Art, Purchase, Friends of
the Department Gifts and matching
funds from The National Endow-
ment for the Arts, 1978 (1978.185.2)

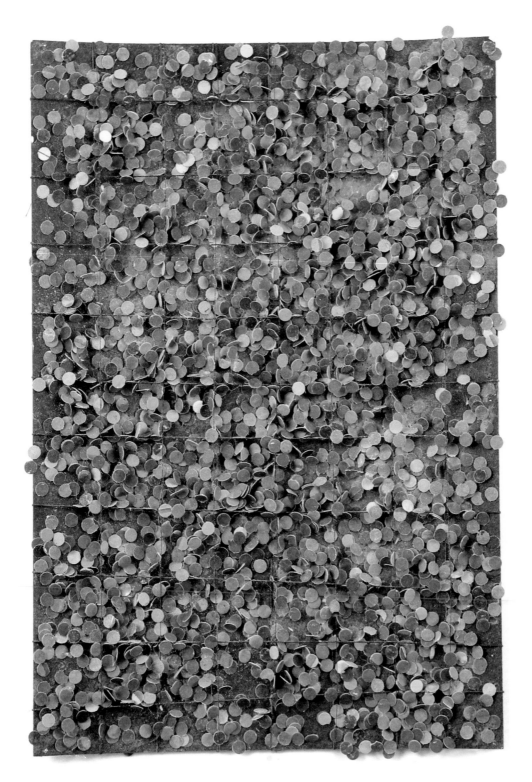

Howardena Pindell
Untitled #23, 1974
20 1/2 x 16 1/8 inches
Watercolor and acrylic on board
Courtesy Sragow Gallery, New York
Photo: A. V. Woerkom

Bathers, 1972

Barbara Chase-Riboud

In a new and unpolluted sea
Fresh from vision
New
New
You and I
You and I
Emerging
Clinking like metal
Shiny on the sand
As wave-washed copper pennies
Anchored by beach lizards
Weighted in shrouds of
Smooth rose pebbles
Attached to
Slow rolling kites
Separated by a
Gritty breeze
That winds down
The space
Between us
As irrefutable as
The Great Chinese Wall
Evaporating sea tears
On you
Sea tears that dry
Leaving small white
Circles of brine
Not like my tears
That remain forever
Undried
As I walk back into that
New and unpolluted sea
Fresh from vision
Old
Old
You and I
You and I
Converging
In the ooze of
Radiolarian skeletons
On the bottom
Of the Arabian sea.

Barbara Chase-Riboud
Bathers, 1972
Aluminum and silk, ed. 3 of 3
148 x 108 x 6 inches
Courtesy of the artist and Stella
Jones Gallery, New Orleans

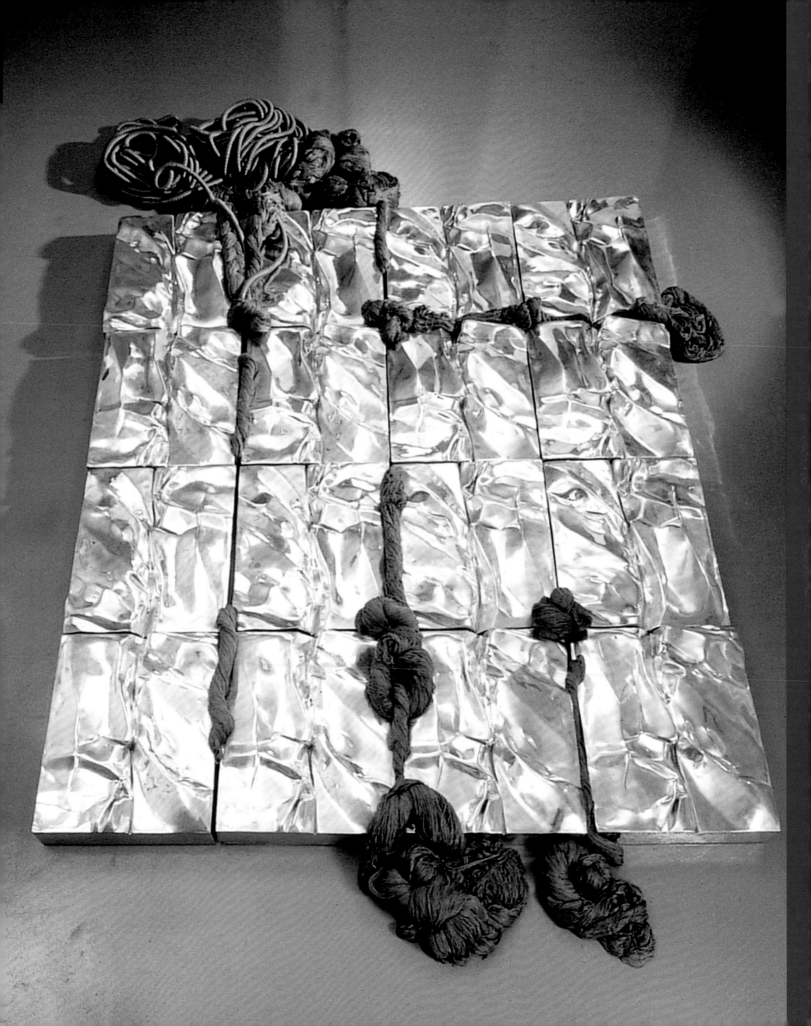

Barbara Chase-Riboud
Untitled, 1966
Charcoal pencil on paper
30 x 21 1/4 inches
Collection of The Museum of
Modern Art, New York, Gift of
Betty Parsons Gallery, 453.1972

Barbara Chase-Riboud
Untitled, 1971
Charcoal pencil and pencil on paper
29 7/8 x 22 1/8 inches
Collection of The Museum of Modern
Art, New York, David Rockefeller
Latin American Fund, 280.1972

Haywood Bill Rivers
Eclipse # I, 1970
Oil on canvas
36 x 36 inches
Collection of Jack Whitten,
New York

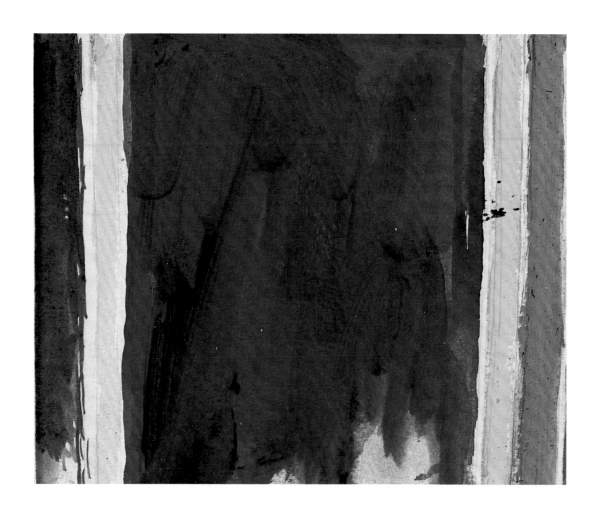

Alma Thomas
Space, 1966
Acrylic on paper
6 x 7 inches
Collection of The Studio Museum
in Harlem, Museum Purchase and a
Gift from E. Thomas Williams and
Audlyn Higgins Williams, 97.9.19

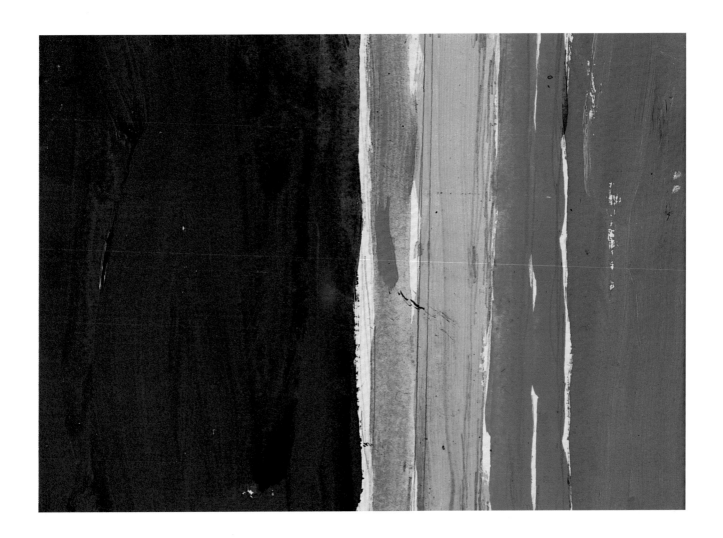

Alma Thomas
Opus 52, c. 1965
Acrylic on paper
7 1/4 x 10 inches
Collection of The Studio Museum
in Harlem, Museum Purchase and a
Gift from E. Thomas Williams and
Audlyn Higgins Williams, 97.9.18

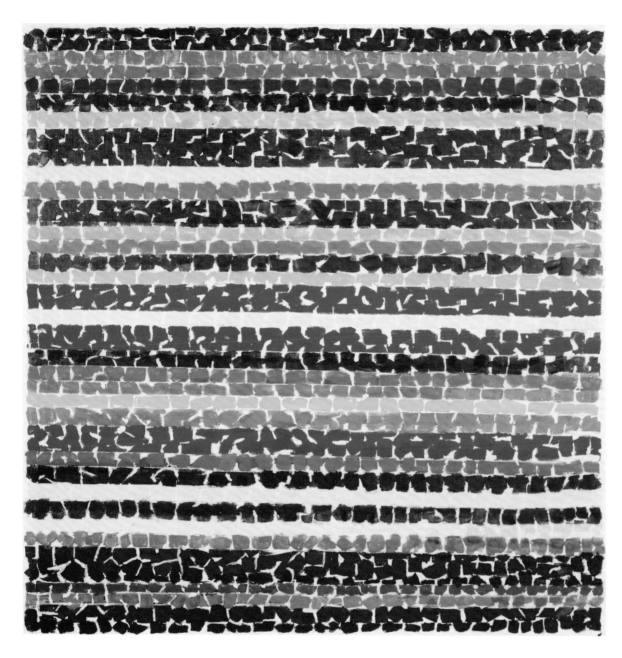

Alma Thomas
Air View of a Spring Nursery, 1966
Acrylic on canvas
48 x 48 inches
Collection of the Columbus Museum,
Georgia; Gift of the Columbus-Phoenix
City National Association of Negro
Business Women and of the artist

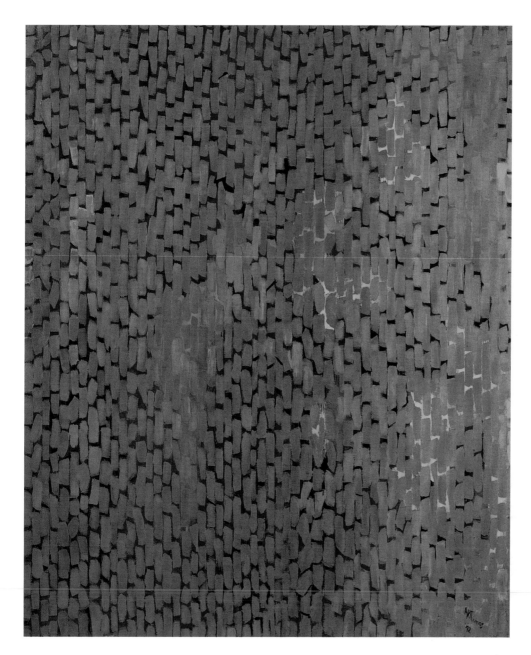

Alma Thomas
Mars Dust, 1972
Synthetic polymer on canvas
69 x 57 inches
Collection of the Whitney
Museum of American Art, New
York; Purchase, with funds from
The Hament Corporation, 72.58

Jack Whitten
Khee I, 1978
Acrylic on canvas
72 x 84 inches
Collection of The Studio Museum
in Harlem, Gift of Lawrence
Levine, New York, 81.9

Jack Whitten
Red Cross for Naomi, 1980
Acrylic on canvas
42 x 42 inches
Courtesy of the artist

William T. Williams
Untitled, 1969
Screenprint on paper
16 x 11 5/8 inches
Collection of The Studio Museum
in Harlem, Gift of Charles Cowles,
New York, 81.2.3

William T. Williams
Untitled, 1969
Screenprint on paper
16 x 11 5/8 inches
Collection of The Studio Museum
in Harlem, Gift of Charles Cowles,
New York, 81.2.4

William T. Williams
Untitled, 1969
Screenprint on paper
16 x 11 5/8 inches
Collection of The Studio Museum
in Harlem, Gift of Charles Cowles,
New York, 81.2.5

William T. Williams
Untitled, 1969
Screenprint on paper
16 x 11 5/8 inches
Collection of The Studio Museum
in Harlem, Gift of Charles Cowles,
New York, 81.2.6

William T. Williams
Trane, 1969
Acrylic on canvas
108 x 84 inches
Collection of The Studio Museum
in Harlem, Gift of Charles Cowles,
New York, 81.2.2

Black Artists and Abstraction: A Roundtable

22 June 2005 at The Studio Museum in Harlem

Louis Cameron / Melvin Edwards / Julie Mehretu /
Lowery Stokes Sims / William T. Williams /
Moderator: Kellie Jones

Black Artists and Abstraction: A Roundtable

LC: Louis Cameron
ME: Melvin Edwards
JM: Julie Mehretu
LSS: Lowery Stokes Sims
WTW: William T. Williams
KJ: Kellie Jones, moderator

Kellie Jones The function of this roundtable conversation is to discuss abstraction by black artists, what was at stake in the 1960s and 1970s, and how that landscape looks in the 21st century? How have things changed?

To start with, can everyone talk about being part of a larger cohort of black artists working with abstract languages, and if that is meaningful?

Lowery Stokes Sims Well, I think your question, of what was at stake, was the whole question of what a black artist should do. It was the 1960s, and you had the Spiral Group on one hand looking at how they could make their art relevant to what was happening politically and socially. You also had a generation of artists coming out of schools like Yale University and other places—Mel coming from California, for example—who had much greater sophistication and sense of connection with events going on in the larger art world. Against that backdrop, artists became much more proactive with anti-Vietnam statements, and then women and minorities came in and talked about inclusion in museums. I'm talking from my perspective of coming into the museum world in 1972. There seemed to be this question about what black artists were supposed to do and how they could be relevant. And I think that there

were very strong delineations, which subsequently disappeared a decade later, between whether you were figurative and "blackstream" [i.e., creating specifically black subject matter] or you were abstract and "mainstream." There was always the assumption that if you were abstract you were not being relevant to your community, that you were just a sellout to the white world, that if you wanted to be a down, relevant black person you did figurative art that had polemical content. Of course, these were broad generalizations, but there were people who had very strong ideas about this.

William T. Williams First of all, an artist is an individual and there is a specific sensibility that he or she has. And hopefully what an artist does is work toward that sensibility.

For me during that period, it wasn't a question of being this or that. It was a question of this body of work that was coming out of me as a human being and as an artist. Now it's relevant to anyone who's sensitive enough to see and understand what I'm doing.

Louis Cameron For me it is kind of interesting that in the 1960s and '70s it seemed like there were a greater number of artists willing to work with abstract languages than there seem to be today.

Melvin Edwards I think all art is abstract. I'm presuming part of the reason Kellie has to start where she does is because we're really talking about post-civil rights movement, post-1950s and '60s, the spirit and the cultural work of black people. Some people were trying to be sure that it was useful, that art could be like a tool or had a place. For me it wasn't a problem.

I know that the earliest art of human beings was figurative *and* abstract. Period. So there was never a time that human beings didn't deal with both modes. To conceive of something from the world you experience, and then create or recreate based on it, is an abstract process anyway. I came out of Phyllis Wheatley High School, a black high school in Houston, Texas, in 1955, and I'd already been exposed to the idea that there's a difference in modes between abstract and figurative art. But that knowledge didn't carry the prejudice that if art was abstract it wasn't relevant to black people. So we're jumping into the middle of an argument—it's like coming to the barbershop on Saturday and whatever's going on, we start there. But that's not where it started.

When I got in the university art environment, of course, they had some arguments, but it didn't take me long to figure out that it was an argument of European origin, and that the academy the Europeans developed in the 16th century was anatomy-based. They just happened to develop it that way. They actually dealt with abstraction even in those periods. Not as a mode or a style, but in concept and processes. Their own systems of dynamics and composition were all abstract, but we don't pay attention to this basic kind of stuff. So we just jump into the argument. Who said we weren't relevant? You think I'm going to listen to some idiot who tells me my stuff is not relevant, or somebody else's stuff is not relevant, when they don't know their ass from a hole in the ground as far as art goes?

I took that attitude all along. I wasn't looking for somebody to lead me somewhere. When I found minds or artists, or people who were creative who I could learn something from, I tried to engage them. This conversation here reminds me of William and I sitting at the old Studio Museum in its first year or two—'69?—and looking out the window and discussing concepts of color and dynamics, and dynamics in motion, color and systems. That wasn't black. It was just two black people doing it, doing it based on a black community and their movement. So why am I going to listen to some people who didn't have the right questions in the first place? It doesn't make sense to answer their questions. It made

much more sense just to try and develop things. We already had people who were working abstractly. Ed Clark is 10 years before this? His abstract work is very significant. One of the reasons I think the art didn't get what it should've gotten in terms of recognition was because of the black community's lack of development economically and aesthetically.

WTW Certainly there were artists during the late '60s and early '70s who were making extraordinary works of art. It's a question of how those works were perceived. How were they accepted or rejected? If this art is not being institutionalized as a body of aesthetics or a body of thought, then it becomes marginalized. The politics of that time marginalized the artists in two ways. Certainly the politics that you're talking about in the black community, with things being relevant or not, that's one way that you become marginalized. But if the larger art world itself is saying, "this is what we think you should be doing, because this is the need we have to serve as a museum," and that reason is political rather than aesthetic, then you're marginalized again.

So where does that leave us as artists? It means the only thing that we had at that moment was each other, and other artists that had sensibilities and were willing to focus in on these issues.

It's interesting, this wasn't as separate as it would seem, like *them* against *us*.

The thing that really comes to mind is if I looked at Sam Gilliam's or Jack Whitten's paintings, or others, and then I went to the gallery, there was no difference in quality between those objects. What was different was the extraordinary amount of resources behind some artists, and how the resources began to institutionalize certain artists and marginalize others.

KJ Let me switch back and let Louis and Julie jump in on this idea about a cohort. I think what Louis was starting to say was, it seems to me, significant, that there are less artists now that you see working abstractly. And Julie, you may want to refute that or whatever, but if you can continue with that thought ...

LC It does seem to me that when Bill and Mel were working there were more artists engaging with abstract languages and more of a community and more intercommunication between those artists. For me it seems like in our generation there are fewer artists working within an abstract continuum. There isn't that kind of intense conversation going on between black artists concerning abstraction and their place in it. My conversations with my cohorts concern the art world more generally, rather than specific approaches to art *per se*.

ME When I met Bill in 1968, I already had been making art for eight years beyond school. I was in Los Angeles, not in the East. I didn't have many conversations with black artists about abstraction. In fact, if anything, there wasn't the communication apparatus that there is now. You can talk about connections between Bill and me and Al Loving, and those starting about 1970, but before that, when Lowery mentioned Spiral—it was those artists who were here in New York, that's all Spiral was. Who was here? And they weren't all abstract artists. It always was mixed. Like I said, the environmental pressure to represent the black community came primarily out of a distorted notion of nationalism in the civil rights era. And you're talking about social realism—social realism didn't come from Africa. We did, but it didn't.

Julie Mehretu That's really helpful to hear because I feel like I've had a lot of discourse with other artists that I've gotten to know through graduate school and residencies, including the one here. And the artists I end up having good relationships with, whether they're abstractionists or artists of color, that's not really what the discourse is about. It's usually that we're interested in similar things in terms of ideas, concepts and our approaches to making art. And outside of that, there are other things, like music, books or movies, that we'll have a common interest in. Sometimes the way things are written about the past, you get this romantic notion that there was this school, a group of people that developed a way of making together, a practice together.

WTW There were times when we would have discussions on a specific topic—color in painting, for instance. We would discuss the structure of color and how it could be used as a vehicle for expression.

Howardena Pindell, Peter Bradley and I were classmates at Yale, and Louis Delsarte and I were classmates at the Pratt Institute. Between undergraduate and graduate school, and thereafter, there has always been at least one other artist I could have a dialogue with about being an artist. Also, I met Jacob Lawrence when I was 14 years old. So I had an idea that it was possible to be an artist. I knew the history of his work and other African-American artists

Louis Delsarte's work is almost purely figurative, but the thing we talked about was not the figuration in his work but how the thing was structured. What was holding it together? There were the intangibles that went into making a work

of art. It's similar to the dialogues Mel and I, and Jack Whitten and I, and Ed Clark, and that whole generation had.

A lot of the dialogue within this generation of artists was because of locale. We all were in New York. We all seemed to have migrated to lofts or to areas in lower Manhattan at a certain time. We were in relative proximity to each other. Sam Gilliam would come up from Washington, so it extended even farther. But what ultimately occurred was, although we had these extraordinary conversations and we would hang out together, when we went to our individual studios we were very different.

LSS I think the questions of context and expectations with regard to these issues are very important because you all come from the perspective of working in studios. But this dialogue about abstraction and figuration goes back to the 1920s, when Alain Locke wrote "The Legacy of the Ancestral Arts" [1925]. He encouraged black artists to look at the intangible qualities, the classicism, the design, the symbology. He gave black artists pretty wide latitude there. Then he came back 20 years later and said, "well, we didn't have such great results." But at the time, the expectations for artists were also channeled into fighting stereotypical images. There is always this appetite

in the black community, which I think exists to this day, for having positive affirmative images that they can recognize. And there's this perception that abstraction doesn't do it.

You can read Norman Lewis writing in 1949, and Romare Bearden before him in 1934, saying in effect that black artists have to get away from the imperative to respond to some kind of social agenda. Lewis told us, "I did it; it didn't work. So I'm going to go back and be true to myself." So, this question of the role of art, as perceived by what the wider society, meaning both the black community and America at large, sees as appropriate for black expression, brings in all these issues about authenticity and trueness, and also community involvement.

What I'm always struck by, in fact, is that, as Mel says, everything is abstract. We don't make art the way we did in Africa. However, one of the sources of abstract non-objective art is African art, so there's no reason why we can't. But I really think that what you're talking about, when we talk about why these questions come up, is the particular context and expectations under which art is made. I think Louis and Julie have to deal with this whole post-modern question of identity and ethos, and when gender and race politics come into it, it would seem that abstraction has no place.

KJ Do you feel that the formal study of art plays a role in the development of this cohort of artists working abstractly? For me it's interesting that many African-American artists working in the 1960s and 1970s—like Mel and Bill—have bachelor's and even master's degrees. And it's even more standard for artists in the younger generation like Julie and Louis. Somehow I feel this professionalization of the field is part of the story. I am also interested in the role of informal study.

JM There are just so many different types of work being made between video, performance, painting and sculpture, I don't know if I agree necessarily with what Lowery said about us having to deal with these post-modern ideas of gender, race, politics or things like that. But as far as us as a cohort, I don't know how to define that. Would it be like Studio Museum artists, Yale or RISD [Rhode Island School of Design] artists, or artists of a certain age, of a certain similar type of background, of similar interests?

It seems to me there are so many more museums now, so many more curators and galleries, so many more avenues and possibilities for you to make whatever kind of work you want. You do what you're doing, Louis, and I'm making what I'm making, and there are artists that have come in and out of the Artist-

in-Residence program here at the Studio Museum making all different types of work. And it's all important and necessary to each of us as individual artists. I do feel like there's a discourse that can happen between all of us here, but I don't think it's necessarily based on what we're going after in our own work.

In school, I needed to think about the process of making, who I was as an individual and an artist, and what I was really trying to do with my work. It was important because it gave me the time, space and attention to develop a working language. I was also in school with some other really good artists and we had a tremendous amount of dialogue. But more than anything, it gave me a clear understanding of the context of the history of art, art-making, what had been made, what the art world had been and the various discourses that took place. We saw how art history is written and re-written by learning what art history books were interesting at a certain time and then became uninteresting in other periods. Right now you have certain schools that are the main feeding schools to the art world here because of their proximity to New York and the active involvement of art critics and curators in them. It doesn't really make for interesting discourse or great art. It seems like they have become trade schools for art

production and galleries. Other than that, I don't know how the school experience would help develop anything right now in terms of a cohort, other than giving a context for what's happened in the past.

LC I agree with Julie in that, in the broad sense, I think formal education fosters a general sense of community with different artists from different places. And at least in my experience, it didn't really foster an experience of belonging to a specific community of African-American artists working with abstract languages. I was in a similar situation as Bill in that I had a number of African-American students in school with me. But I was also lucky because I had the benefit of African-American professors and teachers—Stanley Whitney and John Dowell—teaching me. In terms of formal education versus informal, I think informal becomes very important for me. You don't stop learning when you get out of school. For me research is very important, and learning about artists that came before us, like Bill and Mel, is especially important because we aren't necessarily taught that in school. So we have to take that into our own hands and continue that research so that maybe, at least, we know. But perhaps there's also a possibility of making some kind of connection with the past if one chooses to.

WTW School was really important for me. It focused my time from undergraduate to graduate school. It gave me an extended period where the only thing I had to think about was art-making, the history of art-making and getting together as much information as possible about this activity.

The issue for me then became, now how do I get rid of that formal education? That was the test. The first stage is learning it, and the second stage is getting rid of it so you can develop your own voice within tradition. How do you see yourself fitting into this idea that there are creative people in the world who want to communicate something?

What protects and promotes you as an artist, I think, is your individual vision and how you sustain that vision over a long period of time. Romare Bearden said something to me when I first came to New York and got a little attention. He said, "Bill, remember this is a long-distance activity ... art is made by old men." I took it to mean that it takes time to weed out your impulses, to get other people out of your work and to focus on what you want to do. I was six months out of graduate school when he said that to me, and I've taken it to heart. He said, "take your time in this activity. It doesn't matter what people think you're doing or how successful they think you are. The

only thing that success has to do with is being able to get up and go to the studio another day. That is success." I've really taken that to heart all these years.

That's what I think of when you say technology is "in" and everyone is doing installation, etc. Well, technology is just like a brush—it's a tool. It's not an aesthetic in itself. Ultimately it's the artist and his or her particular aesthetic that modifies that tool.

On the one hand, you have this big umbrella, African Americans that are making abstractions. Well, that's a nice umbrella, but the reality is once you get under that umbrella and you see that each one has a different sensibility, then we have to investigate those different sensibilities and consider how they have contributed to larger ideas about signs and symbols.

ME My education is similar to everybody's here, but different. I didn't go to graduate school. And just in the five-year age difference between William and I, graduate school was just beginning to be an important thing. I didn't come into college thinking about graduate school. But two years after I graduated I was exhibiting my work at the same places where the teachers at UCLA and USC were showing. So I feel I didn't miss graduate school. I had been exposed to

some of what graduate students grappled with. Basically, they tried to develop their individuality as artists, and then they would have to have a show at the end of the two years. Formal education is the minor league; life beyond is for the professionals.

There were a lot of artists who were automatically abstractly figurative or figuratively abstract. You know, they straddled that territory. Like Picasso, but in a more modern kind of way. And Rico Lebrun and Willem de Kooning were slightly different ends of it. Lebrun was in California, de Kooning was here in the East. One of my painting teachers was Hans Burkhardt, who was together with de Kooning and Arshile Gorky, they were friends, three European immigrants in the New York art world in the 1930s. Burkhardt said he and de Kooning were really students compared to Gorky, that Gorky was more advanced than they were. He would bring in actual paintings by Gorky to show us. They were Gorky's copies of Picassos and Cézannes, because that was the way he studied, by making very faithful copies of earlier art.

I know I'm loading this up, but what I'm getting at is that I liked to draw and I evolved notions of abstraction within my work. But it wasn't an issue in those years. You could or you couldn't, or you did or you didn't—nobody cared

too much. The only comment my drawing teacher, who was a very famous artist draftsman from Hungary, Francis de Erdely, had was, "well, if you're going to work that way right now, you're somebody who's trying to work on the 15th floor and you haven't gone up the stairs." In other words, you haven't covered the floors that get you there, you know? You're trying to work with something that you don't understand the basis for.

Now I'm a sculptor. That happened because around my last semester in my BFA at USC, I saw a couple of graduate students welding, and I decided I wanted to learn to weld. I took a night course from one of those students, George Baker. After that I taught myself, really. So I don't have an actual college background of studying sculpture seriously. I thought I was a hotshot painter, and if I'd done it the other way I'd be sitting next to William and we could throw paint at each other instead of me throwing pieces of steel at him, and him throwing paint at me.

So I didn't get to graduate school, but I did get a graduate degree. Yeah, I finally graduated three years ago. I received an honorary doctorate in 2001 from Brooklyn College, thanks, I'm sure, to the recommendation of Mr. Williams. All I can say about formal education is it's like any part of learning. It's the con-

ventional thing that's there, it's one of the possibilities. I see all education like a driver's license. That is, it gives you permission to go out on the street in a vehicle. In this case the vehicle is visual art. It doesn't make you a Grand Prix racer, and it doesn't put you on a high level—it's what you do with it afterwards that counts.

KJ Let's talk about experimentation. In the 1960s and 1970s, the new technologies included light, electronics, plastics, resins and the newly invented acrylic paint. Currently digital technology is the new frontier. How did, or how do, new technologies affect your work, perhaps in terms of things like structure, form, surface, color, illusionism, etc. Maybe at this point we can go further into something that people have talked about somewhat on their own, your relationship to historical abstraction. A colleague was recently talking about how artists make their own art histories. I thought that was really interesting. It's not necessarily about influences, but who people look at and think about at different points of their lives. Is Malevich important for you now? Brancusi?

LC I agree with what Bill mentioned earlier in terms of new technologies just being tools for you to get at a specific end that you're working toward, and that these technologies are not ends in themselves. I know personally I have used the computer to deal with certain geometric forms in my work, for instance to warp the grids that became the basis for my floor pieces. So technology was a tool. It wasn't an end in itself, I just used it to get from Point A to Point B.

I think oftentimes in the most interesting art the technology is invisible, or you don't see its role in the process and it's just another tool like a brush or a pencil or what have you.

WTW Well, I live in a very low-tech world: opening a can of paint, spilling the stuff out and doing something with it. It is the tactile that interests me, what that material can do and how you can exploit it. For me that's at the heart of painting.

LC But isn't that a technology issue also, when Kellie mentions acrylic paint being invented in the '60s, and the very new and specific qualities of it?

WTW It is, it is. In the '60s I met Lenny Bocour when I was an art student at the Skowhegan School of Painting and Sculpture, and he liked my work. Bocour was the owner of Bocour Paint at that point and he supplied me with paint from 1966 until 1979. I would call him up and say, I need such and such and such, and he would say, "okay, you'll have it tomorrow." And the paint would arrive at my studio. Cases of it. Then he'd come down to the studio and say, "Bill, I have this new material that we're working on in the shop. Why don't you take it and see what you can do with it." I'd work with it and then report back to him, "well, Lenny, I like it but it's too stiff. Is it possible to make this stuff so it's more fluid?" And he would say, "we have this chemical over here that can do that." So I had the benefit of the paint manufacturer and all of the technological advances.

I was not the only one who had this type of relationship with Bocour. Ken Noland had that as well, as did Jules Olitski and many others. Ken Noland was my downstairs neighbor at 654 Broadway. Bocour was interested in their work and we were all using acrylic paint.

ME Well, he got good art in return.

WTW Well, he did. He came down once a year and chose a painting from the studio. For me that was incidental to the larger relationship we had and the technical information I had access to. I could basically pick up the phone anytime and call him and if there was a technical problem he'd either send someone down or tell

me to come up—to the plant, which was on the West Side—and we'd work it out.

KJ Jack Whitten had a similar connection to the Xerox Corporation. He had a grant where Xerox installed a machine in his studio for one year so he could experiment with it. So this was something going on at the time, corporations, Bocour or Xerox, pairing up with artists and having them experiment with their products. We also saw this formalized on the West Coast, where the Los Angeles County Museum of Art put together an art and technology project by pairing artists with corporations. The resulting work was brought together in a show there, *Art and Technology*, in 1970. So this was in the air.

ME You mention Jack and Xerox. I had an earlier experience in 1962-63 with duplication equipment because I worked for an animation company in Los Angeles. Graphic Films was owned by Lester Novros, who was the father of the painter David Novros. My work there was nothing to do with art, really. I was a driver and a go-getter, taking film to the lab, etc. Most of the technical people there became the ones that created the film *2001: A Space Odyssey*, one of the breakthrough pieces of cinema on space. That's the kind of place it was in terms of the level of skill and interaction.

While I was there, Graphic Films got a project from Wright-Patterson Air Force Base near Dayton, Ohio. The project was to do a film that would help convince the government to fund NASA, so the guys in the back room designed a thing we called the "dynamic soaring device," basically a paper airplane that is now recognized anywhere as the Space Shuttle. But it was actually invented by these artists in the back room throwing paper airplanes back and forth at each other and talking about volleyball nets as concepts for space stations. When the government realized how potent these ideas were, they invoked a policy where any idea that developed while working on this project belonged to the government, not to these people. So you don't see their names anywhere.

I'm putting this all together because in 1962 I got an assignment to do storyboards using copy equipment at Graphic Films. But I was moving from painting to sculpture at that moment, which is partly the reason I didn't pursue any further photo-cinematic experimentation in my own work, because I realized if I got involved in this cinematic and two-dimensional visual world I would just move away from sculpture. So I closed the door on that, so to speak.

Similarly, in 1966 I did some work for Dwan Gallery repairing abstract ki-netic sculpture by Jean Tinguely. He had made a bunch of sculptures for Dwan Gallery and left them in a warehouse, completed but not functioning. Dwan needed somebody to make them work. Through certain connections they brought me in, and in doing that I learned that Tinguely wasn't as complicated as he appeared to be. The pedals he used to start the pieces, well, they were the same as the one on my mother's electric sewing machine. Meanwhile, I had Tinguelys and principles of kinetics to play with in my own studio. When I got to New York, it turned out that the reputation that I could fix kinetic sculpture preceded me. LeFebre Gallery got my name from somewhere and called me, so I went and looked at and repaired a couple of Pol Burys. Then I got sent to Chicago at the Museum of Contemporary Art to make the Tinguelys work for them. After that I had to stop—I was doing stuff for other people's art, not for my own.

But what I'm getting at is that doing that work also became experimental thinking for me, and I learned that artists experiment both in their own work and outside their work.

In a related vein, people talk about Jackson Pollock and his importance for abstract expressionism and abstraction in general. Pollock attended David Siqueiros' New York Experimental

Workshop. His change and development in abstraction, his engagement of large-scale painting, came after working with Siqueiros. In the late 1930s Mexican muralists had worked for 15 to 20 years with large-scale painting and its dynamic spatial and technical problems. But most of what people refer to is the social content of those murals. Similarly, when Bill and I were doing the Smokehouse murals, we made certain decisions that didn't allow for the storytelling part, but we did change spaces with the dynamics of it.

WTW Most of all the artists in the late '60s and the late '70s were painting very large paintings. Part of that was the idea of making the art have presence, but it also involved wanting to have absolutely nothing to do with that concept of a window on the world, which easel painting signifies, or the notion of the arena that the abstract expressionists had.

The linoleum paintings I did in the mid-'60s preceded pattern and decoration by almost 20 years. And it's not as if the art world didn't know about these pieces. Dore Ashton and Irving Sandler both wrote about these paintings.

When I got out of graduate school I wrote a proposal that had to do with an artist-in-residence program in a community. My interest was in going to a community, or the community I grew up in, and bringing this body of information I had gained to benefit other or younger artists within that community who probably had similar skills.

The trustee of the Studio Museum read my proposal, interviewed me and hired me to start an Artist-in-Residence program. That program had its start at the first site of the Museum over the liquor store on Fifth Avenue [2033 5th Avenue]. It was a loft, a factory going out of business that had a lot of sewing machines in it. Mel and I physically cleaned that space out for the Artist-in-Residence program. That was the beginning.

The purpose that I saw for the Artist-in-Residence program was that you must have a place within the community to develop artists. If you wanted to make art that was going to be relevant to a people, it had to be art that had been internalized—not just depicted. If you get artists in a community over that prolonged a period of time, they are going to internalize something about that community. It didn't matter what they did other than participating in a continuum where you bring those resources back to that community. Well, the Artist-in-Residence program is now in it's 35th year or so.

JM In school I really learned a lot about what other artists had already experimented with in terms of physical material—paint. My process was really one of peeling everything away. So I went back to just ink and paper. Before I went to graduate school I was using so many different materials without really having a clear understanding of what I was doing and what I was really trying to make. So there was this process of just taking everything back to a very minimal, very basic, way of working, and then adding stuff if it made sense conceptually with what I was thinking about.

I brought new materials into the work because they seemed necessary, and I would experiment with them to mimic papers, vellum, mylar and whatever I was playing with, and to create paintings and drawings through that process. There was a reason for me to use acrylic paint in a certain way. I wanted to mimic certain kinds of signs or symbols. In a sense it was like hip-hop. I was bringing in other people's experimentation, basically sampling, and pulling these parts together and mixing in my marks to create a visual language that was mine as well as historic.

By playing around with things like acrylic paint and silica, I developed a material that I now work with a lot, but it was not like the kind of experimentation with paint that you're talking about. Right now, with the way computers operate, any shop in New York can make

almost anything for you. So the big question is how I find materials to work with that make sense of what I want to try and say, or what I'm really trying to develop in terms of the work itself?

KJ I was going to ask, how do you use the computer? How does it come up in your world?

JM I usually make many drawings in the computer using Illustrator, Photoshop, FreeHand or whatever, and then project parts and pieces of those drawings onto canvas and paint them. I then work freely on the painting with other projections, free-hand drawing and painting. Then I take a digital photo of the painting and experiment with it as an image on the computer. I can print out certain elements, project them and paint them back into the painting. I also have an architecture student working with me part-time developing AutoCAD drawings of particular spaces for the work. So the computer really operates as another tool, another resource in the studio, another place for experimentation.

KJ Let's discuss figuration v. abstraction and issues of race. Is there still as much at stake in terms of the black body? Is there still pressure to depict that, as there was in the 1960s and 1970s?

Both Louis and Lowery mentioned this notion that there are perhaps fewer black people working non-objectively, working abstractly, than there were during the time of this cohort that I've talked-ed about in the 1960s and '70s. Is that because there is some kind of pressure to depict the black body? Do you feel that pressure, or is that just a decision? Is it just that there is a larger menu now and people can choose from A, B, C, D, E, F, and there's nothing punitive? Or do you think that people may still feel that they have to work in that way? Or maybe it's due to this push from film and video? Or simply that abstraction as such is not in style?

Also, what is your relationship to the art world as an abstractionist or creator of non-objective works? What is your relationship to the art world as an artist of color? Are there different ways into the art world for you? And finally, do you feel a certain invisibility as a black artist working abstractly?

LC I was going to say I do think the "larger menu" is an issue. When you talk about the '60s and '70s, so much has happened between then and now. There are so many more options in terms of media and ideas and what people are dealing with that I think people just make choices—maybe choices not to work in certain

ways or deal with abstract languages, or at least not in the abstract ways that we're talking about. I think that's a big part of it.

WTW I guess the question is about enlarging the canon. I think what we're talking about is the relatively narrow focus of the art world in terms of what was available and possible at a given time. What we're trying to do here is say that not only are there other things possible, but also that we have to enlarge the vision of what American art is and what art is, rather than trying to make it inclusive. If we only want to be inclusive, then basically you do what everyone else is doing. If you're trying to enlarge the canon though, you take a different approach.

I believe what numerous artists are trying to do is enlarge the canon, and not necessarily just become a participant. I think this may get to Louis' question of why so many young artists are not embracing abstraction. You said there are fewer. What seems to me usually occurs—and most artists I think are coming out of university programs now—is that the first thing you respond to as an artist is that body of information you're presented with in school—what "is happening," or what is, as someone said, the discourse. So everyone enters that discourse.

Well, the artists that are good come out of that discourse and look real different than when they started. The ones that just get there and stop there, that becomes another problem. I think what a lot of young artists do is they look around, they see the artists that are popular, and they do versions of that popular thing for a while. The problem we have is that a curator can just pick up on that thing that's popular.

So if you have 30 artists you can identify some doing some version of body politics, sometimes the quality doesn't matter, it's just part of style. The bigger issue though is, okay, everyone is doing that—how do we now look at that and begin to identify the aesthetic and its parameters? We have some way of entering that body of work and having a dialogue about it, rather than just identifying style. I think that's what the dialogue was about with us in the late '60s. It wasn't really a discussion about abstraction, it was a discussion about aesthetics and quality. It didn't matter whether the person was representational or abstract. It had to do with developing a canon of aesthetics.

KJ I just want to bring in two examples. The first African-American artist to represent the U.S. at the Venice Biennale was Robert Colescott in 1997. Last year, Kehinde Wiley had a show at the Brooklyn Museum—a major show—of large, figurative paintings. For some reason, and maybe these are just isolated incidents, it seems that among African-American or black artists in this country, figurative artists, more than abstractionists, are the ones that get picked up by the mainstream. These are just two recent examples.

Now I know Sam Gilliam had a retrospective at the Corcoran Gallery of Art in Washington, D.C. [Oct. 15, 2005–Jan. 22, 2006]. Also I presented Martin Puryear as the U.S. exhibition for the Sao Paulo Bienal in 1989. These are both people working abstractly, but it still seems to me that black artists that get more exposure in a mainstream context work figuratively or representationally. Take Bearden, for instance.

JM Well, I think that in some ways there's something to be said for that. I think there is also a lot of really great abstract work being made right now that is really challenging, bringing up a lot of questions and getting a lot of airtime. David Hammons' show at Ace [Nov. 2002] maybe tops them all. But some strange things can happen: Holland Cotter wrote a review of Ellen Gallagher [at the Whitney Museum of American Art, Jan. 27–May 15, 2005] recently that said, "finally I can talk about this work because I can really pull apart the politics," whereas her previous show at Gagosian Gallery [Sept. 14–Oct. 23, 2004] was just not mentioned because it was more abstract than any of her shows before. There weren't any googly eyes, there wasn't anything that really demonstrated the "race dynamic" in this work. It feels like, if you're an artist of color, this is the kind of work you can make. An artist who's working with a figure or representation, you can clearly pull apart the politics in it if that's what's going on. This, it seems to me, is largely an issue with consumers of art. For the art world and for the critical world, the politics of race is something to talk about. An artist of color making abstract paintings, it's that much harder to talk about race in the work.

WTW But why should it be talked about at all?

JM I don't know that it should be talked about. That's another discussion, and I'm not sure that these definitions are even important. Ultimately it is the work that matters—abstract, representational, figurative—it is not at all what I'm concerned with. I am concerned with the development of my work, my language, whatever it is, whatever is necessary for me. So I'm not saying that race in abstract art should be talked about, I'm

just saying that that's why it doesn't get talked about at all, it's why this work is almost silenced.

WTW But doesn't that put a ball and chain around me if it doesn't happen?

JM What I'm saying is I think they should talk about your work. We should know about your work and your major contribution. It should be there as part of this continuum, alongside everyone else who was working at the same time—Chuck Close, Kenneth Noland, Elizabeth Murray—not separate, but right there. But not to talk about it at all is to say that it didn't happen.

WTW That is absolutely right.

JM What I'm saying is I don't know that that approach is so different right now. I think it's really different in certain ways in the commercial art world, in terms of the presence. I feel like I've been able to have a pretty good presence—being included in major museum exhibitions, like at the new MoMA or the new Walker, or being visible in magazines, people writing about the work, etc. But I do feel like it's still difficult. Chris Ofili's really abstract paintings and drawings don't get written about frequently, only those with black figures do. I think some artists are moving towards figuration because

that's what they do, and other artists are doing abstract work because that's the only thing they can do. I don't think that good artists choose a way of working because of its commercial or critical value in the art world. Whatever you develop into as an artist, you develop into. I have developed a language of working that can be both, but I do think that things are still discussed in terms of an artist's identity. It feels as if every time I'm mentioned it's like "Julie Mehretu, Ethiopian-American painter." It's not just a painter who's working on …

WTW Does that bother you, the identification as an Ethiopian-American artist? Because I've come to the point that whoever you are is fine. If they want to talk about me as being Ethiopian-American, African-American, none of that really matters. It's the body of work that I've spent my life doing that's important.

JM That matters.

WTW Right. Those are social kinds of categories that they're placing you in, right? So we had this discussion in the early '70s too—"well, he's a black artist." Yeah, okay, that's fine, I'm a black artist. I grew up with that, I know that as a black person. But that's not telling me ultimately about the work. That's where

my objection comes in. Tell me about the work. I know my own history, I know the sociopolitical context you're placing me in. But if you talk about my work, then that's a different issue.

JM I agree.

WTW You never get questions about the work.

JM What I'm trying to ask is what do you think caused that silencing?

WTW The artist is not silenced.

JM No, of course not.

WTW The artist keeps going. I think very often there are social, economic pressures that silence one artist over another. One artist gets promoted, another one gets promoted. I think a lot of that has to do with economics and not necessarily with aesthetics.

ME That's the art business.

WTW Exactly, the business. And as an artist I'm not in control of that.

JM What about criticism?

WTW Criticism is a similar kind of thing.

Normally when the works are criticized they're in a context where they can be criticized. In other words, they're in a museum show, they're in a gallery show. Well, if that was objective, if everyone got a number and everyone put their work up randomly, that would be one thing. But there's a selection process that gets it on the wall. That selection process already created a kind of filtering device.

Maybe it's the critical eye that differs. In other words, Kellie's eye is drastically different than Thelma Golden's eye, or the eye of a curator younger than either of them. In other words, I think each generation is connected to an aesthetic or wants to define an aesthetic. And it seems to me they go about choosing those things that help them define an aesthetic. That's the difference between Clement Greenberg choosing the show and Irving Sandler choosing the show, or Max Kozloff choosing the show. Each one had an agenda, and the shows were chosen in relation to those agendas. The artists they championed had to do with the particular agenda that they were proposing. I think it's no different now.

JM No, it's no different. It's absolutely the same.

ME But then you come to our part of the question, the sense that we're here because of race. We have to say that, frankly, we don't have the galleries, the museums. Yes, there are two or three exceptions, but you say mainstream ... my stream is as main as any! But everybody knows when they say mainstream they don't mean black people.

JM You mean we don't have black galleries?

ME I mean we don't have a society of black people that have the resources and power to present us and what we do at the same level that the others have.

LC Isn't the Studio Museum that?

ME Yes and why did we create a museum like this? Because we didn't have one. How many do we need? Probably one, at least, in every major city in the United States. Because that's what everybody else has. The Studio Museum is an attempt to provide us with some of that, but it's minor compared to our numbers. We're upwards of 30 million people in this society. We're upwards of at least 500 significant, potentially significant, artists. Who can show those people in a 10-year period? That's 50 shows a year. The Studio Museum, one place, cannot do it. Where are the collectors and others who can support that? That's what makes it. Those are just facts.

LC But should that pressure be put on any one institution, or any specifically African-American institution?

ME It just is. It's not a question of should it be. It *is*. Because that's all there is. If there ain't but one thing to carry the load, it gets all the weight.

LC Right, right.

WTW I think for your generation of artists, different venues have opened up to you at an earlier stage, and there are probably many younger curators in museums that certainly seem to be more inclusive in their thinking. Mel and I are in our 60s. We were emerging artists, then mid-career artists ... Now what are we?

KJ Old masters!

WTW Old masters. Thank you. But somehow we don't get into any of those categories. Consequently what occurs is that our thinking about this activity is very different than how people of another generation think.

JM Yes. That's why I'm asking if it feels the same as when you were working, when you first moved to New York and when you were doing well in New York. Is

it the same kind of animal now, just bigger? Like the same context now, just bigger? I feel like it's very different. It seems like it has to be. I mean, there are so many artists who are showing in all different kinds of contexts. We have a couple of black dealers in town—galleries, a couple of African-American critics, great black curators, museum directors, collectors. Sotheby's largest shareholder is a black-owned investment firm headed by a black woman. You have a little bit more … but …

WTW What you have is an infrastructure now. You have an infrastructure that didn't exist in the late '60s, early '70s.

ME It's similar. It's not the same, but it's similar.

WTW Part of the infrastructure is certainly the contribution of this museum as a training ground for so many of those who have gone on and now are in a place where they can make a difference. It took that many years to begin to put all of that infrastructure in place. The bright future is that—it's the future, where a lot of these things will be unraveled. The body of work is there, it's just a question of time. Art history is one of those things that's constantly being reassessed and rewritten.

Artists' Biographies

Frank Bowling

Born 1936, Guyana
Lives and works in London, England

EDUCATION
1962 Royal College of Art, London, England

SELECTED SOLO EXHIBITIONS
1980 Tibor de Nagy Gallery, New York, NY
1979 Tibor de Nagy Gallery, New York, NY
1978 *Frank Bowling Retrospective*, Polytechnic Art Gallery, Newcastle upon
 Tyne, England
1977 *Selected Paintings, 1976–77*, Acme Gallery, London, England
 William Darby Gallery, London, England
1976 Watson/de Nagy and Company, Houston, TX
 New Paintings, Tibor de Nagy Gallery, New York, NY
1975 William Darby Gallery, London, England
 Tibor de Nagy Gallery, New York, NY
1974 Noah Goldowsky Gallery, New York, NY
1973 Noah Goldowsky Gallery, New York, NY
 Gallery Center for Inter-American Relations, New York, NY
1971 Whitney Museum of American Art, New York, NY
1966 Terry Dintenfass, New York, NY

SELECTED GROUP EXHIBITIONS
1980 *Maps*, John Michael Kohler Art Center, Sheboygan, WI
 Summer Exhibition, Royal Academy, London, England
 Hayward Annual, Hayward Gallery, London, England
1979 *Another Generation*, The Studio Museum in Harlem, New York, NY
 The Russell Cotes Modern Artists Exhibition, Russell Cotes Art Gallery &
 Museum, Bournemouth, England
 Contemporary Caribbean Artists ... African Expressions, Bronx Museum,
 Bronx, NY
 British Art Show, Mappin Art Gallery, Sheffield, England
1978 Selected Works for Tibor de Nagy Gallery, Mint Museum, Charlotte,
 NC
 476 Broadway, New York, NY
1977 *25 Years of British Painting*, Royal Academy, London, England
 Artists' Map, Philadelphia College of Art, Philadelphia, PA
1976 *The Golden Door: Artist Immigrants of America, 1876-1976*, Hirshhorn
 Museum & Sculpture Garden, Washington, DC
1973 *Whitney Biennial: Contemporary American Art*, Whitney Museum of
 American Art, New York, NY
1972 *Two Guyanese Painters: Frank Bowling and Philip Moore*, Guyana
 Consulate, New York, NY
1971 *Contemporary Black Artists in America*, Whitney Museum of American
 Art, New York, NY
 Whitney Biennial: Contemporary American Art, Whitney Museum of
 American Art, New York, NY
 Some American History, Rice University, Houston, TX
1970 *Objects of American History: The Black Experience*, De Menil Foundation,
 Houston, TX
 Afro-American Artists: New York and Boston, Museum of Fine Arts,
 Boston, MA
1969 *5 + 1*, State University of New York at Stony Brook, Stony Brook, NY
 Whitney Annual: Contemporary American Painting, Whitney Museum
 of American Art, New York, NY
1968 *The Obsessive Image*, Institute of Contemporary Arts, London, England

1966 First World Festival of Negro Art, Dakar, Senegal
1964 *The London Group*, Tate Gallery, London, England

AWARDS, GRANTS, RESIDENCIES AND FELLOWSHIPS
1977 Arts Council of Great Britain Award
1975 Creative Artists Public Service (CAPS) Grant, New York State
 Council of the Arts
1973 John Simon Guggenheim Memorial Fellowship
1972 Visiting Artist Program, New York State Council of the Arts
1968 Artist-in-Residence, New York State Council of the Arts, Critics
 Choice Program
1967 John Simon Guggenheim Memorial Fellowship
1967 Painting Prize, Edinburgh Open 100, Edinburgh, Scotland
1966 Grand Prize for Contemporary Art, First World Festival of Negro Art,
 Dakar, Senegal

SELECTED PUBLIC COLLECTIONS
American Telephone and Telegraph Corporation, New York, NY
Arts Council of Great Britain
Boca Raton Museum, Boca Raton, FL
Calouste Gulbenkian Foundation, Lisbon, Portugal
Carmen & G.R. N'Namdi Collection
Chase Manhattan Bank, New York, NY
Currier Gallery, Manchester, NH
Crawford Municipal Art Gallery, Cork, Ireland
De Menil Foundation, Houston, TX
Herbert Art Gallery & Museum, Coventry, England
Herbert F. Johnson Museum, Cornell University, Ithaca, NY
John Simon Guggenheim Foundation
Kresge Art Center, Michigan State University, East Lansing, MI
Lloyd's of London, England
London Lighthouse, England
Metropolitan Museum of Art, New York, NY
Museum of Fine Arts, Boston, MA
Museum of Modern Art, New York, NY
National Gallery of Jamaica, Kingston, Jamaica
New Jersey State Museum, Trenton, NJ
Neuberger Museum, State University of New York, Purchase, NY
Owens-Corning Fiberglass Corporation, Toledo, OH
Port Authority of New York, New York, NY
Rhode Island School of Design, Providence, RI
Royal College of Art, London, England
Tate Gallery, London, England
University of Delaware, Newark, DE
University of Liverpool, Liverpool, England
Victoria & Albert Museum, London, England
Whitney Museum of American Art, New York, NY

SELECTED BIBLIOGRAPHY

"Arts Reviews," *Arts* (Jan. 1976): 14.
"Reviews and Previews," *Art News* (Feb. 1974): 92.
Artforum (Feb. 1974): 72.
Arts (Dec. 1973): 57.
New York Times (Dec. 1, 1973): 27.
Art News (Dec. 1971): 13.
Arts (March 1966): 70.
Art News (Jan. 1966): 11

Barbara Chase-Riboud

Born 1939, Philadelphia, PA
Lives and works in Paris, France

EDUCATION
1960 MFA, Yale University, New Haven, CT
1957 BFA, Tyler School of Art, Temple University, Philadelphia, PA

SELECTED SOLO EXHIBITIONS
1980 Bronx Museum, Bronx, NY
1977 *Documenta VI*, Kassel, Germany
1976 Kunstverein, Freiburg, Germany
 Musée Reattu, Arles, France
1975 Musée d'Art Contemporain, Tehran, Iran
 United States Cultural Center - Dakar, Senegal; Accra, Ghana;
 Freetown, Sierra Leone; Bamako, Mali; Tunis, Tunisia
 Betty Parsons Gallery, New York, NY
1974 Merian Gallery, Krefeld, Germany
 Kunstmuseum, Düsseldorf, Germany
 Staatliche Kunsthalle, Baden Baden, Germany
 Musée d'Art Moderne, Paris, France
1973 Indianapolis Art Museum, Indianapolis, IN
 Detroit Institute of Art, Detroit, MI
 Gold: Sculptural Jewelry, Leslie Tonkonow Gallery, New York, NY
 Berkeley University Museum, University of California, Berkeley, CA
1972 Betty Parsons Gallery, New York, NY
1970 *Four Monuments to Malcolm X*, Bertha Schaefer Gallery, New York, NY
 Hayden Gallery, Massachusetts Institute of Technology, Cambridge,
 MA
1966 Cadran Solaire, Paris, France

SELECTED GROUP EXHIBITIONS
1980 *Afro-American Abstraction*, P.S.1, Queens, NY
 Miroir d'Encre, Brussels, Belgium
1979 *Another Generation*, The Studio Museum in Harlem, New York, NY
1977 *Les Mains Regardent*, Centre Georges Pompidou, Paris, France
 The Object as Poet, National Museum of American Art, Washington, DC
 European Drawings, Art Gallery of Ontario, Toronto, Canada
1976 *Sydney Biennial*, Sydney, Australia
1975 *Merian Gallery Group Show*, Cologne Art Fair, Cologne, Germany
1974 *Woman's Work –American Art '74*, Museum of the Civic Center,
 Philadelphia, PA
 Masterworks of the Seventies, Albright-Knox Gallery, New York, NY
1973 *Whitney Biennial: Contemporary American Art*, Whitney Museum of
 American Art, New York, NY
 Seven Sources of Inspiration, Betty Parsons Gallery, New York, NY
1972 *Gold*, Metropolitan Museum of Art, New York, NY
1971 *Jewelry as Sculpture as Jewelry*, National Gallery of Canada, Ottawa,
 Canada
 Contemporary Black Artists in America, Whitney Museum of American
 Art, New York, NY
 Contemporary Jewelry, Art Gallery of Ontario, Toronto, Ontario,
 Canada
 Salon de la Jeune Sculpture, Musée National d'Art Moderne, Paris,
 France
 Two Generations, The Newark Museum of Art, Newark, NJ
 Annual Exhibition of Sculpture, Whitney Museum of American Art,
 New York, NY
 Salon des Nouvelles Réalités, Galeries Nationales d'Exposition du
 Grand Palais, Paris, France
1970 *Afro-American Artists: New York and Boston*, Museum of Fine Arts,
 Boston, MA

1966 First World Festival of Negro Art, Dakar, Senegal
1965 *The New York Architectural League Selection*, Commercial Museum,
 Philadelphia, PA

AWARDS, GRANTS AND FELLOWSHIPS
1958 John Hay Whitney Fellowship

SELECTED PUBLIC COLLECTIONS
Berkeley University Museum, University of California, Berkeley, CA
George Pompidou Museum, Paris, France
Metropolitan Museum of Art, New York, NY
Museum of Modern Art, New York, NY
National Collections, Paris, France

Ed Clark

Born 1926, New Orleans, LA
Lives and works in New York, NY

EDUCATION
1952 L'Academie de la Grande Chaumiere, Paris, France
1951 Art Institute of Chicago, Chicago, IL

SELECTED SOLO EXHIBITIONS
1980 Syracuse University, Syracuse, NY
 North Carolina A&T State University, Greensboro, NC
 Contemporary Arts Center, New Orleans, LA
 Retour aux Sources, Galerie d'Art Mitkal, Abidjan, Cote d'Ivoire
 Retrospective: Ed Clark, The Studio Museum in Harlem, New York, NY
1979 Orozco Chapel, Guadalajara, Mexico
 Icarus Odyssey, Centro de Arte Moderno, Guadalajara, Mexico
 Another Generation, The Studio Museum in Harlem, New York, NY
1978 Louisiana State University, Baton Rouge, LA
1977 *Yucatan Series*, Peg Alston Arts, New York, NY
1976 Sullivant Gallery, Ohio State University, Columbus, OH
1975 James Yu Gallery, New York, NY
1974 South Houston Gallery, New York, NY
1972 Western Michigan University, Kalamazoo, MI
 Lehman College, New York, NY
1969 *Two Man Show: Ed Clark and Lawrence Kalawale*, Morgan State
 University, Baltimore, MD
 American Embassy, Paris, France
1966 Gallerie Creuze, Paris, France

SELECTED GROUP EXHIBITIONS
1980 *Ed Clark, Adger Cowans, Bill Hutson*, Yolisa House, New York, NY
 Journeys, Two Views: Recent Paintings by Ed Clark and Bill Hutson,
 Black Enterprise, New York, NY
 Afro-American Abstraction, P.S.1, Queens, NY
1979 Randall Gallery, New York, NY
1978 Peg Alston Arts, New York, NY
1977 Tenth Street Days, New York, NY
 Contemporary Black Art: A Selected Sampling, Florida International
 University, Miami, FL
 Graphic Arts Exhibition: A Selected Sampling, Ankrum Gallery, Los
 Angeles, CA
1976 *Bicentennial Banners*, Hirshhorn Museum and Sculpture Garden,
 Washington, DC
1974 Academy of Arts and Letters, New York, NY
1973 *Fall Exhibitions*, Aldrich Museum of Contemporary Art, Ridgefield, CT

Whitney Biennial of Contemporary American Art, Whitney Museum of
 American Art, New York, NY

1971 *DeLuxe Show*, Menil Foundation, Houston, TX

1970 *Afro-American Exhibition*, Museum of Fine Arts, Boston, MA
 Afro-American Artist Abroad, Baltimore, MD

1969 *Trois Noirs U.S.A*, American Center of Artists, Paris, France

1964 Svea, Stockholm, Sweden

AWARDS, GRANTS, RESIDENCIES AND FELLOWSHIPS

1980 Artist-in-Residence, Syracuse University, Syracuse, NY

1978 Artist-in-Residence, Louisiana State University, Baton Rouge, LA

1976 Artist-in-Residence, Ohio State University, Columbus, OH

1975 Creative Artists Public Service (CAPS) Grant, New York State
 Council of the Arts

1973 Art Institute of Chicago, Chicago, IL

1972 National Endowment for the Arts Award

SELECTED PUBLIC COLLECTIONS

Aldrich Museum of Contemporary Art, Ridgefield, CT

American Express, New York, NY

Ariel Capital Management, Chicago, IL

Bartech Corporation, Livonia, MI

Burrell Advertising, Inc., Chicago, IL

The California Afro-American Museum, Los Angeles, CA

Chase Manhattan Bank, New York, NY

Coca Cola Bottling, Philadelphia, PA

Dunn and Brad Street, New York, NY

Evan-Tibbs Collection, Washington, DC

Harlem State Office Building, New York, NY

Hooven Dayton Corp., Dayton, OH

Independence Bank, Chicago, IL

James E. Lewis Museum, Morgan State University, Baltimore, MD

Johnson Products, Chicago, IL

Kresge Museum, Kalamazoo, MI

Louisiana State University, Baton Rouge, LA

Mitchell/Tytus and Co., New York, NY

Museum of Modern Art, Salvador, Bahia, Brazil

Museum of Solidarity, Titograd, Yugoslovia

Schomburg Center for Research in Black Culture, New York, NY

Sims, Varner and Associates, Detroit, MI

The Studio Museum in Harlem, New York, NY

Syracuse University, New York, NY

TLC Beatrice International Holdings, Inc., New York, NY

U.B.M. Construction Co., Chicago, IL

University of Kentucky, Lexington, KY

William and Gloria Johnson Collection, Detroit, MI

SELECTED BIBLIOGRAPHY

Wilson, Judith. "Edward Clark: Directions." *Art in America* vol. 69
 (Jan. 1981): 119.

Feldman, Anita. *Edward Clark: A Complex Identity*. Exh. cat. New York:
 The Studio Museum in Harlem, 1980.

Kingsley, April. "Ed Clark's Luminous Expanses." *American Rag* vol.1
 (Feb. 1980).

Arts Magazine (Nov. 1975): 8.

Art International (Jan. 1973): 64.

Melvin Edwards

Born 1937, Houston, TX

Lives and works in New York, NY

EDUCATION

1965 BFA, University of Southern California, Los Angeles, CA

SELECTED SOLO EXHIBITIONS

1980 *Melvin Edwards: Recent Sculpture, Fragments and Larger Work*, 55
 Mercer, New York, NY

1979 Johnson Atelier, Mercerville, NJ

1978 *Melvin Edwards*, The Studio Museum in Harlem, New York, NY

1976 Morgan State University, Baltimore, MD

1972 Wright State University, Dayton, OH

1970 Whitney Museum of American Art, New York, NY

1968 Walker Art Center, Minneapolis, MN

1965 Santa Barbara Museum of Art, Santa Barbara, CA

SELECTED GROUP EXHIBITIONS

1977 Henry O. Tanner Gallery, Brandywine Workshop, Philadelphia, PA
 Drawn and Matched, Museum of Modern Art, New York, NY

1976 Fisher Art Gallery, University of Southern California, Los Angeles, CA

1975 Cinque Gallery, New York, NY
 76 Jefferson, Museum of Modern Art, New York, NY

1974 *Lines*, Carpenter Gallery, Dartmouth College, Hanover, NH
 Extensions: Edwards, Gilliam, Williams, Wadsworth Atheneum,
 Hartford, CT

1973 Arnot Art Museum, Elmira, NY
 Sculpture Three, World Trade Center, New York, NY

1972 Art Institute of Chicago, Chicago, IL

1971 *Arts as Advocate*, Museum of Modern Art, New York, NY
 Aldrich Museum of Contemporary Art, Ridgefield, CT

1970 Minneapolis Institute of Art, Minneapolis, MN
 Rental Gallery, Museum of Modern Art, New York, NY
 Whitney Annual, Whitney Museum of American Art, New York, NY
 Dimensions of Black Art, La Jolla Museum of Art, La Jolla, CA

1969 California Crafts Survery, Fine Arts Gallery of San Diego, San Diego, CA
 5 + 1, State University of New York at Stony Brook, Stony Brook, NY
 X to the 4th Power, The Studio Museum in Harlem, New York, NY

1968 *30 Contemporary Black Artists*, Minneapolis Institute of Art,
 Minneapolis, MN
 Barnsdall Art Center, Los Angeles, CA

1967 Esther Bear Gallery, Santa Barbara, CA

1966 Esther Bear Gallery, Santa Barbara, CA

1965 Esther Bear Gallery, Santa Barbara, CA

1965 *Five Younger Los Angeles Artists*, Los Angeles County Museum, Los
 Angeles, CA

1965 Richard Grey Gallery, Chicago, IL

AWARDS, GRANTS AND FELLOWSHIPS

1975 Guggenheim Foundation Fellowship

1973 Creative Artists Public Service (CAPS) Grant, New York State
 Council of the Arts

1970 Cassandra Foundation Award
 National Endowment for the Arts Award

1969 Cassandra Foundation Award
 Santa Barbara Art Association Award

1966 Long Beach Museum of Arts Award

1965 New Talent Purchase Grant, Los Angeles Contemporary Art Council

1964 John Hay Whitney Fellowship

Alma Thomas

(1891–1978)

Air View of a Spring Nursery, 1966
Acrylic on canvas
48 x 48 inches
Collection of the Columbus Museum, Georgia; Museum Purchase and Gift of the Columbus-Phoenix City National Association of Negro Business Women and the artist

Mars Dust, 1972
Synthetic polymer on canvas
69 x 57 inches
Collection of the Whitney Museum of American Art, New York. Purchase, with funds from The Hament Corporation, 72.58

Opus 52, c. 1965
Acrylic on paper
7 1/4 x 10 inches
Collection of The Studio Museum in Harlem, Museum Purchase and a Gift from E. Thomas Williams and Audlyn Higgins Williams, 97.9.18

Space, 1966
Acrylic on paper
6 x 7 inches
Collection of The Studio Museum in Harlem, Museum Purchase and a Gift from E. Thomas Williams and Audlyn Higgins Williams, 97.9.19

Jack Whitten

Acrylic Collage #1, 1973
Acrylic on paper
10 1/4 x 8 1/2 inches
Courtesy of the artist

Khee I, 1978
Acrylic on canvas
72 x 84 inches
Collection of The Studio Museum in Harlem, Gift of Lawrence Levine, New York, 81.9

Red Cross for Naomi, 1980
Acrylic on canvas
42 x 42 inches
Courtesy of the artist

Structural Series I, 1974 (study)
Toner on paper
9 1/2 x 13 1/2 inches
Courtesy of the artist

William T. Williams

Trane, 1969
Acrylic on canvas
108 x 84 inches
Collection of The Studio Museum in Harlem, Gift of Charles Cowles, New York, 81.2.2

Untitled, 1969
Screenprint on paper
16 x 11 5/8 inches
Collection of The Studio Museum in Harlem, Gift of Charles Cowles, New York, 81.2.3

Untitled, 1969
Screenprint on paper
16 x 11 5/8 inches
Collection of The Studio Museum in Harlem, Gift of Charles Cowles, New York, 81.2.4

Untitled, 1969
Screenprint on paper
16 x 11 5/8 inches
Collection of The Studio Museum in Harlem, Gift of Charles Cowles, New York, 81.2.5

Untitled, 1969
Screenprint on paper
16 x 11 5/8 inches
Collection of The Studio Museum in Harlem, Gift of Charles Cowles, New York, 81.2.6

Staff

Cheryl Aldridge, Director of Development

Ayhan Aydinalp, Museum Store Sales Associate

Timotheus Ballard, Custodian

Fitzroy Bernard, Operations Manager

Marc Bernier, Head Preparator

Angelo Borrero, Fire Safety Director

Robert K. Brown, Membership Associate/Associate Database Administrator

Rashida Bumbray, Exhibition Coordinator

Andres Carrion, Building Supervisor

Joseph Centeno, Security Officer

Wilfredo Colon, Custodian

Carmelo Cruz, Finance Manager

Jackson Devis, Security Officer

Ali Evans, Public Relations Manager and Editor

Jamie Glover, Museum Store Manager

Thelma Golden, Director and Chief Curator

Nola Grant, Security Officer

Rashawn Griffin, Artist-in-Residence 2005-06

Malcolm Harding, Security Officer

Hallie S. Hobson, Associate Development Director, Membership and
 Donor Relations

Rujeko Hockley, Curatorial Assistant

Sandra D. Jackson-Dumont, Director of Education and Public Programs

Jonell Jaime, Manager, School and Family Programs

Fitzroy James, Security Officer

Paul James, Security Officer

Dennell Jones, Human Resources/Executive Assistant

Christine Y. Kim, Associate Curator

Carol Martin, Education and Public Programs Assistant

Sheila McDaniel, Deputy Director, Finance and Administration

Rosi Ng, Executive Assistant to the President

Savala Nolan, Public Relations Coordinator

Karyn Olivier, Artist-in-Residence 2005-06

Clifford Owens, Artist-in-Residence 2005-06

Nisette Oyola, Museum Store Sales Associate

Terry Parker, Security Supervisor

Joshua M. Phillippe, Security Officer

Ronny Quevedo, Museum Educator, Expanding the Walls Coordinator

Reynold Riboul, Security Officer

Norris Robinson, Security Officer

Josefina Rojas, Security Officer

Jared B. Rowell, Executive Assistant to the Director

Khalid Sabree, Security and Deputy Fire Safety Office

Deidre Scott, Director of Technology

Shanta Scott, Museum Educator, Intern Coordinator

Socrate Simeon, Security Officer

Lowery Stokes Sims, President

Leonard Smalls, Security Officer

Cassandra Soler, Administrative Assistant and CIG Coordinator

Emmanuel Souffranc, AP Bookkeeper

Vivienne Valentine, Manager, Grants and Corporate Relations

Teddy Webb, Security Officer

Travis Willomon, Security Supervisor

Susan Wright, Special Events Manager

Trisha Young, Security Officer

Shari Zolla, Registrar

This publication was organized at The Studio Museum in Harlem by Ali Evans, with the assistance of Rashida Bumbray, Rujeko Hockley, Jerlina Love, Savala Nolan and Jared Rowell.

Edited by Samir S. Patel
Design by The Map Office, New York
Printing by Cosmos Communications, Inc., New York
The typeface used in this volume, Freight, was designed by Joshua Darden.
Printed and bound in the United States